CONNECTICUT
GHOST STORIES
AND LEGENDS

CONNECTICUT
GHOST STORIES
AND LEGENDS

THOMAS D'AGOSTINO + ARLENE NICHOLSON

Haunted America

Published by Haunted America
A Division of The History Press
Charleston, SC 29403
www.historypress.net

Back cover: Courtesy of Jeremy D'Entremont.

Unless otherwise noted, all photographs are by Arlene Nicholson.

First published 2011
Second printing 2013

Manufactured in the United States
ISBN 978.1.60949.181.9

Library of Congress Cataloging-in-Publication Data
D'Agostino, Thomas, 1960-
Connecticut ghost stories and legends / Thomas D'Agostino and Arlene Nicholson.
p. cm.
Includes bibliographical references.
ISBN 978-1-60949-181-9
1. Haunted places--Connecticut. 2. Ghosts--Connecticut. I. Nicholson, Arlene. II. Title.
BF1472.U6D3325 2011
133.109746--dc23
2011023107

This book is dedicated to all our family and friends. Thanks for being there.

CONTENTS

Acknowledgements 9
Introduction 11

Seventh Day Baptist Cemetery: The Green Lady 13
Hale Homestead 17
Devil's Hopyard 24
Makens Bemont House 28
The Old Homespun Farm 31
Fort Griswold's Gruesome Ghosts 35
The Headless Horseman of Canton 39
Gay City State Park 43
Tory Den 50
Nineveh Falls 53
The Black Dog of the Hanging Hills 56
Charles Island 59
New London's Ledge Light 63
Bara-Hack: The Village That Echoes the Past 68
Captain Grant's Ghosts 74
The John York House 79
Nipmuc Fishing Fires 84
Daniel Benton Homestead 87
The Yankee Pedlar Inn 93
The Ghosts of Pachaug State Forest 96

CONTENTS

The Leather Man 101
Windham Textile Museum 106
Frog Pond and Bridge 110
The Morin House 114
The Bradley Playhouse 118
A Brief Collection of Ghostly Grimoires 122

Conclusion 137
Bibliography 139
About the Authors 143

ACKNOWLEDGEMENTS

I would like to give special thanks to John Zontock of Northwest Connecticut Paranormal for his valuable contribution, Connecticut Paranormal Encounters and Research for its contributions and photo of anomaly, Barry A.A. Dillinger of Creepy Connecticut for his contribution and factual findings on many of the sites, Lauren Neslusen of Quiet Corner Paranormal, Putnam Historical Society, Anthony Dunne and Mark Langevin of WGBY, Beverly York and CT Landmarks for their assistance, Greg Best, Ron Kolek and Ron Kolek Jr. of New England Ghost Project, Dave Shultz, Mary Deveau, Leonard Alderman, David Brierley, Michael Carroll and Hailey Fish, Tammy Eustis of the Killingworth Library for supplying a treasure-trove of information, everyone at the Putnam Library, Bob Duncan, Patricia Green, Ann Paietta, the Poulliots, Marc and Lori Morin and all the rest who wished to remain anonymous but were instrumental in the making of this book.

INTRODUCTION

New England is a veritable hodgepodge of haunts. Whenever I am asked what the scariest place is, a long list unfolds in front of me. It is almost impossible to pin one place down as the number one in the coveted fright of fame. No less than anywhere else, Connecticut seems to have some of the most bizarre haunts known. In fact, many consider the Nutmeg State a ten on the weird and bizarre haunts meter. In researching this book, I also found that Connecticut has more legends and folklore than any other state in New England. That would certainly make Connecticut a legendary place to either visit or reside.

In the pages that follow, you will be transported to places that you would think only the imagination could conjure, but they do exist and, as far as accounts and legends are concerned, are truly haunted. Some are incredible stories that may not be as supernatural as they are intriguing, but they do nonetheless represent the peculiar and incredible history and mystery that makes Connecticut so magical.

You will discover such people as the famous Leather Man, a colonial ghost still holding sentry over his post, spirits of famous battles, heroes that never seem to fade with the passing of time, early settlers, a headless horseman and Indian ghosts. Places such as Devil's Hopyard, Ninevah Falls and Village of Voices, along with other ghost towns and historic sites, await your arrival, as the inhabitants who haunt these places still have something to convey to the living.

There will be stories that you may have heard that are not within the pages of this tome. There are several reasons for this. Among them is the fact that they took place on private property, or perhaps their sites no longer exist. Some accounts were proven to be the work of a creative imagination for late-night campfire scares. In other cases, please do not feel slighted if your favorite haunt did not make it into the book. There were only so many that could be chosen to fill this volume, and although I would have loved to cover all of the incredible places that make up Connecticut's "other side," I had to leave some for next time. In the meantime, grab your book and hit the road to adventure. Many others have, and they are ready to relate lots of ghostly tales and legends about a place called haunted Connecticut.

SEVENTH DAY BAPTIST CEMETERY

THE GREEN LADY

The Seventh Day Baptist Cemetery is host to an eerie entity called the Green Lady. Unlike most female ghosts that cavort around cloaked in a shimmering white radiance, the Green Lady glows with an emerald sheen. The ghost is said to be the wraith of Elisabeth Palmiter, who died at the age of thirty on April 12, 1800. Circumstances surrounding her tragic demise are lost to antiquity and have become host for legend and speculation. It is surmised that Elisabeth drowned in the swamp next to the graveyard. Some say her husband, Benjamin, was there and did not, or could not, help her. Other accounts state that her husband had ridden into town to procure some necessities when a bad snowstorm hit. He could not travel in the blinding flurries and decided to wait out the blizzard. Elisabeth got nervous when he had not returned and ventured out in the dead of night to try to find him. During the snowstorm, she got lost and drowned in the nearby swamp. When her husband returned, he found her in the swamp still clad in her beautiful green dress. Other legends say he actually murdered her and threw her into the muck to cover up his evil deed. No matter what legend you choose to believe as true, the fact is that the Green Lady has been spied wandering the road that runs adjacent to the burial ground for over two centuries. Those who witness the specter say she is not sad but, on the contrary, has a rather pleasant expression on her face. She is strikingly beautiful, surrounded by a green mist as she meanders down the road where the burial ground is located. Some say, as opposed to a green mist, she appears to be covered in a green slime from the swamp where she met her unfortunate demise.

There are stories circulating that the home next to the graveyard is also haunted. It is believed that the house was once hers. There is a portrait of her that can be seen from the road. Many say that the portrait is also haunted as it watches over those who make their way past the old dwelling toward the cemetery. Whether this part is true or not is a matter of conjecture, but as for the ghost, numerous people have witnessed her midnight ramblings along the old road. Some witnesses have claimed to have also seen the spirit of her husband, eternally searching for his lost bride.

Members of Connecticut Paranormal Encounters and Research investigated the graveyard, and although they did not capture any EVPs (electronic voice phenomena), they did get what appears to be an anomaly near Elisabeth's grave. A very strange mist, rising and swirling into some sort of form, emanated from her grave site. The burial ground, consisting of thirty-five known burials, is mostly stripped of its stones. The Green Lady's stone was replaced but has disappeared once more. Many others are gone as well. The place is heavily patrolled at night, and the neighbors keep a watchful eye for anyone trying to get into the cemetery during the twilight hours. The property is owned by the New Britain Public Works, so trespassing for any reason other than historic research is prohibited.

The Seventh Day Baptists journeyed to Burlington from Rhode Island. Many of them were descendants of the Roger Williams congregation that migrated from the Massachusetts Bay Colony to found the Ocean State. The area was originally called West Britain. The residents established the Seventh Day Baptist Church on September 18, 1780. On October 18, 1796, a man named Jared Covey donated a half acre of land for the purpose of a public burial ground. This excerpt comes from *A Book of Records for the Seventh Day Baptist Society*. It relates a lot about the burial ground's official beginning.

At a meeting of the Seventh Day Baptist Society and others holden at the house of Jared Covey on the 12th day of Oct 1796, made choice of Dea. Amos Burdict Moderator and Silas Covey, Clerk. Voted that the meeting be adjourned to the 9th day of November at 6 O'clock P.M. at the same time.

Having met agreeable to adjournment the moderator being absent made choice of Elisha Covey to lead in sd [said] meeting and whereas Jared Covey presented to the meeting a deed of a piece or parcel of land laying at the southeast corner of the ninth lot in the fourth division in Bristol containing about half an acre for the purpose of a public burying ground with this consideration of sd Society, fencing sd land and giving the privilege of pasturing sheep on the same upon which consideration sd meeting as a

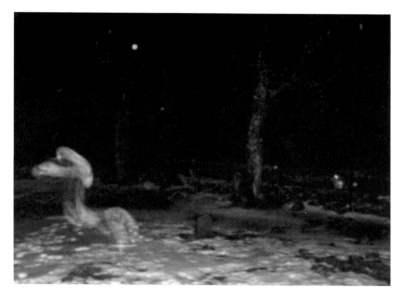

A strange mist rises from the grave of Elisabeth Palmiter at the "Green Lady Cemetery." *Courtesy of Connecticut Paranormal Encounters and Research.*

Society accepted the present whereas it is necessary to have a committee to superintend the fencing of sd land. Voted that Elias Wilcox be a committee to superintend sd business.

Voted that Elisha Covey take charge of sd deed and the records of sd meeting. Voted to adjourn to the fourth Monday in Oct. next at 6 O'clock P.M. at the house of Jared Covey.

Within this writing are two very interesting points that were pertinent at the time. One is that it was not called a cemetery but, rather, a burying ground. The word cemetery did not actually come into our language as a description of a final resting place for our loved ones until the dawn of the nineteenth century. This came into vogue with the larger, more elegant garden cemeteries that are now prevalent in our society. The other aspect, more important to the settlers of the time, was the fact that their livestock be allowed to graze on the land, despite it being a burial ground. This was quite common throughout New England when land was donated or sold for that purpose. The townsfolk did not mind all too much either, as they had a built-in landscape crew in the form of sheep and cattle to keep the grass trimmed neatly around the stones.

Although this writing dates the official transfer of the land at 1796, the site had been used as a burial ground beginning in 1780 with the burial of John Davis, son of Reverend Davis, pastor of the congregation. John Davis was part of Captain Pettibone's company in the Revolutionary War. He died on December 10, 1780, at the age of twenty-nine. Pastor Davis, born September 10, 1723, died at the age of sixty-eight on August 29, 1792. According to one record, he is recorded as having the oldest written stone in the yard. In any case, the deed made it official, and so it was given the name of the Seventh Day Baptists.

The Sabbatarians, as they were called, were plagued with strange deaths during the period from 1810 to 1820. One died after falling from a ladder, and another woman was hanged while repairing a lamp in her home. One man died when a recently dug well collapsed on him, and another member was killed when a tree mysteriously fell on him. Although these incidents were labeled as accidents, one must think how such bizarre occurrences could transpire in such a short time. Was the case of the Green Lady a mere accident, or is she still returning to tell someone something?

In 1820, the Seventh Day Baptists abandoned their holdings and headed west to Brookfield, New York. Perhaps the strange deaths that plagued the congregation became, to them, a sign that the land was not as hallowed as they first believed. Upon their hasty departure, the townsfolk of Burlington took over the properties and began burials of their own in the small cemetery. The last recorded interment is that of Charlotte Spencer, who died on October 14, 1881.

The exact whereabouts of the cemetery is not available, but one can find it by asking the Burlington officials and getting permission to visit. Otherwise, these accounts should be enough to sate the supernatural appetite.

HALE HOMESTEAD

About twenty years prior to this writing, Nathan Hale was given the honor of becoming Connecticut's state hero. Everybody knows the story of how Hale became a spy for the American cause. He disguised himself as a Dutch schoolmaster, crossed enemy lines and obtained information vital to the progress of the Patriot forces. Unfortunately, he was captured on September 21, 1776, while attempting to escape across the enemy's stronghold. William Howe, a British commander, tried him as a spy and sentenced him to hang on the following day. At the gallows, he faced his fate proudly by saying something to the effect of, "I only regret that I have but one life to lose for my country."

Of course, that was a paraphrase taken from one of the greatest plays of all time, *Cato* by Joseph Addison. Undoubtedly, the words of scene four, act four—"What pity is it that we can die but once to serve our country"— were fresh on his mind when he went to the gallows. Being a Yale graduate and schoolteacher, Hale would have been very familiar with the work. Hale, Patrick Henry and even George Washington orated many quotes from the play. In some cases, Washington would enact scenes from the work for his troops.

Five years after Hale was executed, the *Independent Chronicle* and the *Universal Advertiser* from Boston ran a story about the event, stating that Hale actually said, "I am so satisfied with the cause in which I have engaged, that my only regret is, that I have not more lives than one to offer in its service." In *Haunted Heritage* by Michael Norman and Beth Scott, they speak of a diary entry

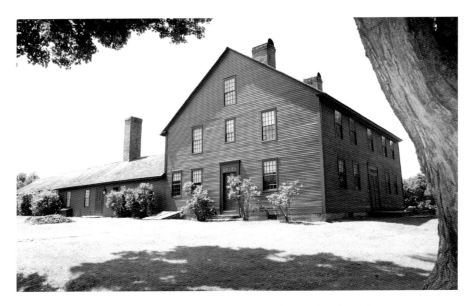

The haunted Hale Homestead in Coventry is home to famous family spirits.

written by a British captain named Frederick MacKensie in which he wrote that Hale said while at the gallows, "He thought it the duty of every good officer to obey any orders given him by his commander-in-chief." Other newspapers offer a variety of quotes from that famous moment.

At this point, it does not matter exactly what he said or where Hale got his inspiration. His immortality rests in the undying love and devotion he had for the cause of liberty and freedom of the people. Today, he is still a symbol of liberty and bravery. He may still be lingering in an effort to observe how we have prospered from his sacrifice, as a few ghosts of the Hale family haunt the farm where he was born and raised. Perhaps others who have graced the walls of the home over the years may remain there as well.

The Hale Homestead is on twelve acres of a five-hundred-acre state park. Evidence of the original home where Nathan was born sits just a few yards from the present home. Parts of the original structure were incorporated into the newer one. The home is open for tours and holds many special events throughout the year. Richard Hale, a deacon and justice of the peace, built the original house in 1746. Richard married a local woman, Elizabeth Strong, and together they had twelve children. Ten of them survived to adulthood, which in those days was a great number.

Nathan, born in 1755, was the sixth child of nine boys and three girls. Nathan was twelve years old when his mother died giving birth to her twelfth child in 1767.

Deacon Hale then courted and married Abigail Cobb Adams, a wealthy woman from Canterbury. She had three teenage daughters who came to live with them. It was obvious that the original home would not accommodate such a considerable crew, so they dismantled it and built a larger one using portions of the old structure. This is the sizeable dwelling that visitors see to this day as they tour the grounds of the homestead.

Nathan graduated from Yale University and became a schoolteacher in East Haddam and New London before joining the Continental army. By 1775, young master Hale had become first lieutenant and showed great promise of a brilliant military career. In 1776, Nathan volunteered to sneak behind enemy lines on Long Island to obtain information crucial to the fight for freedom. Unfortunately, Nathan was captured and hanged a few days later at the age of twenty-one. He never had a chance to rest his bones in the newer house, having left to fight for the Revolution before it was built. History reports that his body was never found, although there is a monument in his honor resting within the confines of the Nathan Hale Cemetery at Wagunbaug Lake in Coventry. Five other brothers also served in the colonial army with Nathan. The enemy forces captured two other brothers. One brother, Joseph, spent time chained up in a prison ship until he was traded for a British soldier. Three of the Hale children died from wounds received during the struggle for freedom from England.

The house remained in the Hale family for several generations. As many as twenty people may have occupied the residence at one particular time. When a person died during the eighteenth and nineteenth centuries, it was common to have him or her laid out in the home. During the winter months when the ground was frozen, the deceased might have been stored either in the basement or, as in the case of the Hale home, in the attic until the spring thaw allowed the family to dig a proper grave.

Much time had gone by since Deacon Hale had built the home, and this passing of time took its toll on the old abode. By 1914, the house was in shambles. George Dudley Seymour (1859–1945) acquired the estate and began extensive renovations of the property. Seymour was an admirer of Hale and his accomplishments. He wrote not only about the life and death of Nathan Hale and his family but of some strange accounts that occurred in the home as well.

These ghostly happenings began almost immediately after Seymour became acquainted with the estate. According to an account written in Seymour's journal, he and a friend traveled to Coventry to view the manor. As they arrived, his friend alighted from the coach and scurried to get a glimpse inside the little schoolroom Deacon Hale had built for his children. When he peered through the pane, he came face to face with a gent in colonial dress. The entity gave a stern look through the panes and then vanished as the man stood, stunned by the visage he had just witnessed. They toured the home, and he was even more startled when he saw a portrait of the deacon himself. It was the exact face that had peered at him through the schoolhouse window.

Mr. Seymour was not the only one to witness the ghostly phenomena. The ghost of a former housekeeper in a long white dress wanders about the house. It is reported that the spirit may be that of Lydia Carpenter, the Hales' former family servant. Witnesses have spied her sweeping upstairs, moving about in the kitchen, gliding down the halls and peeking around doors. It appears the centuries have not affected her dedication to keeping the homestead tidy, as she is still very active in her toils.

Some guests and caretakers have attested to the rattling of chains in the cellar. It has been surmised that they might be from Joseph Hale, who died of tuberculosis (then called consumption) in the home. During the war, Joseph was imprisoned on a British ship, and he is somehow eternally reliving those moments in the cellar of the house, rattling the chains that kept him from escaping.

Mary and George Griffith became caretakers of the house in 1930. They lived there for many years and observed countless strange incidents that could not be rationally explained. One day, Mary watched as her husband walked out to the barn to milk the cows. Moments later, she heard footsteps thumping down the back stairs. She and her husband were the only occupants of the building, and no one had entered or left other than Mr. Griffith. The Griffiths believed that John, Nathan's brother, and John's wife, Sarah, may have been to blame for some of the noises in the house. The Griffiths claimed that this couple was among the spirits they encountered during their tenure at the Hale Homestead. But the exact culprits who spooked the Griffith couple still remain a mystery, like many of the haunts within the Hale Homestead.

The home was deeded to Connecticut Landmarks Society in 1940 and is presently furnished to exact specifications of the room's descriptions in Johnathon Hale's 1803 inventory taken after his death in 1802. Both John and his wife, Sarah, died of consumption in the house.

Arlene and I, along with fellow investigator Andrew Lake, were invited to tour and investigate the house. Rochelle Simon, Elizabeth O'Brien and Beverly York of the Connecticut Landmarks Society greeted us with gracious welcomes and proceeded to give us a guided tour through the historic chambers. Each of the docents had something to share about the ghosts of the Hale home.

The first room we entered was a small parlor. As we stood around talking, the fan on the floor used for cooling the room turned off and back on. This happened three times. We looked for faulty wiring and perhaps a bad plug, but none was the case. Although not conclusively paranormal, it was rather uncanny nonetheless.

In the next room was a portrait of Deacon Hale. One of the tour guides, Tina, was showing the house to a family of three. The six-year-old child was completely misbehaving, running through the rooms and touching things. He ran into the room where the deacon, being a justice of the peace, often held court to settle disputes between the locals. This is also where the portrait is suspended upon the wall and is aptly named the Judgment Room. The little boy came running out of the room in a panic, screaming, "There is a man in the room!" Tina told him it was just a painting and led him into the room to show him. The boy shook his head and said, "There was another man in here just like him, a real one." At

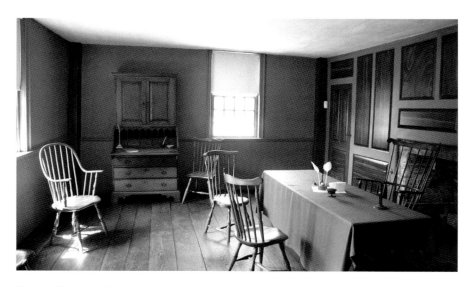

Deacon Hale's study, where his ghost has been witnessed still hard at work.

that point the family had to leave the house, as the boy was too disturbed by the sighting. Beverly then interjected jokingly, "Let that be a lesson to all, don't misbehave in the Hale Homestead."

As we toured the upstairs, there was a sudden sound of the door banging and some footsteps from the first floor. Andrew inquired if there was anyone else in the house. Beverly went down to investigate but came up perplexed. Her search of the downstairs revealed that the door had been secured and there was no one else in the house besides our small party. We took EMF (electromagnetic field) readings and recorded for EVPs once more, but all was silent and still in regard to any paranormal activity. Beverly then told us a story of two guides who had an experience in the home. One of the guides heard someone upstairs and thought it was the other giving a tour. She called out, "Are you upstairs?" and a voice answered, "We are up here." She then proceeded to the barn, where she met the other guide. Kind of confused as to how the guide would be back at the barn so fast, she asked her who she had just guided on the tour of the house. The other guide answered, "I have not done a tour yet, I have been here the whole time." The only entrance to the house was in plain view of where they both stood. The two guides cautiously ventured into the home to survey the situation, but no one was in there. If someone had entered or left the building, they would have noticed.

We decided to try a vigil in the room where Nathan's trunk and rifle are exhibited. Our meters were still not picking up any unusual activity, and the home seemed very peaceful. We then climbed the stairs to the attic, where the family held their loved ones who had passed away prior to the spring thaw for burial. This is where Elizabeth had an experience that she explained as such: "I was leaving the house one day. It was a very dismal Sunday afternoon and there was no sun at all. As I looked up, I saw something glowing in the attic window. It was a tall strange light that did not look real. I thought I might have left a light on. Later I went to the attic and noticed that there is only one light and it is completely blocked from the window by the massive chimney."

We then ascended to the attic, where we performed some EVPs and took some pictures of the window where Elizabeth witnessed the occurrence. We all reviewed the pictures and noticed a strange flickering light in one of them. Other than that, the Hale home was quiet.

A paranormal investigation is much like fishing. With the right equipment, knowledge and a little luck, you just might catch something. Based on the accounts of those who work and tend to the site, we firmly believe that

The attic window of the Hale Homestead, where an unidentified ghost was seen peering out on the yard.

the Hale Homestead still lodges some of America's famous family within. Whether you meet a ghost or not, the Hale Homestead is an awesome place to visit. The beautiful grounds and farmland only add to the enchantment of the historic site. Check out the house and many events that are going on year round. Perhaps you will see why so many have stayed there long after they should have.

Contact the Connecticut Landmarks Society at www.ctlandmarks.org for more information.

DEVIL'S HOPYARD

The name Devil's Hopyard strikes fear in some, but to others, it is a natural parcel of wonder and adventure. A search for the origin of the name "Devil's Hopyard" reveals a few arguable versions as to its moniker, but none of them is verifiable, and all are likely to be born of the instability that laces through fact while on the poetic road to local folklore. One of the most popular of these stories is about a man named Dibble who grew hops along the Eight Mile River for use in his robust and intoxicating moonshine. Dibble would serve this nectar of exhilarating drunkenness to any and all who beckoned. His parties were usually out of control, and all who came drank freely from the tubs of turpentine.

One mother in town found her son beyond his reason due to the moonshine and cursed the devil brew master for his vile drink. She convinced many of the local folk that Dibble was in league with the prince of darkness, trying to corrupt the chaste youth of the town. Those who went down to Dibble's Hopyard were no better than the evil antagonizing rummy himself. It seems that through usage of cursing Dibble's Hopyard, the area became known as Devil's Hopyard. There are records of several farmers having hopyards in the area, but there is no mention of a landowner named Dibble. However, Dibble might have been a tenant.

Another tale focuses on the potholes near the falls that are some of the finest examples of pothole stone formations in this section of the country. Perfectly cylindrical, they range from inches to several feet in diameter and depth. Stones being swept downstream in the swift current formed these

potholes. The stones became trapped in an eddy, where they spun around and around, wearing a depression in the rock. When the rock wore down, another would catch in the same hole and enlarge it. We know this now, but to the early settlers, the potholes were a great mystery that they tried to explain with references to the supernatural. The ominous gorge, pockets in the ledges where demons could hide, the Chapman Falls' thunderous crescendo into the Eight Mile River below and the rushing river itself were foreboding scenes for the pious settlers of the region. The falls are conveniently located along Devil's Hopyard Road, where one can view them from their commencement down the ledge or, if you wish to descend to the bottom of the gorge, from the bank of the river.

There are many legends that are written of the devil sitting atop Chapman Falls, tail slung over his shoulder, playing his hellish violin while witches cackle and stir their sinister brews in the potholes below. On stormy nights, they would gather to cast spells and recite incantations. Their cauldrons were the potholes beneath the falls, and they stood around swirling their evil concoctions amid the rumble of thunder and the flashes of lightning. The devil, perched on the ledge above, was illuminated with a hellish blaze of fiery light as he entertained the hags with his fiddle. As for the holes in the rocks, the settlers thought that the devil had passed by the falls, accidentally getting his tail wet. This made him so irate that he burned holes in the stones with his hooves as he bounded away. When looking up at the falls, one can certainly envision where the devil might make his perch on the edge of the cliff. In fact, the ambience almost entices the vision out of your imagination and into reality.

One night, a lone adventurer dared to pass through the hopyard during the witching hour. In an instant, shapeless forms leapt from the ledges and trees near the falls to the ground and began chasing the frightened man. They accosted him, but he managed to escape and find safe haven in the nearest tavern. There he ranted of his encounter with the devil's minions in the cursed hopyard. Some claim he may have had a few too many samples of liquid hops before wandering into the yard.

One more story concerns the rebellious son of a minister in nearby Millington named Abraham Brown. As the tale is told, the son was forever on the wrong side of the path of rectitude. He would mock his minister father, Obadiah, during services, but that was just the beginning. One night he decided to break into the church and steal the sheepskin cover that lay draped over the altar. He was sentenced to serve one year in the local hoosegow for this crime. He came out no better for the wear. In fact, he had

adopted the Indian doctrine of a happy hunting ground and other Indian ways of life. He criticized his father's ways, saying they were ludicrous and without foundation. His father, outraged to the fullest, ordered him out of his home forever. He soon disappeared and was never seen or heard from again. Allegory states that Abraham was taken by the devil in the hopyard and carried below to serve his penance for his sins. The story sent out a clear message that the devil was waiting at the hopyard for those who may be less than pious. It can be assured that Sunday service saw a major rise in attendance after that story circulated.

There is one traceable historical record that places a certain George Griffin on the property prior to 1800. Griffin ran a small malt house on his farm. He grew hops in a clearing called the "hopyard" in the area that now bears its name. The malt house went out of operation around 1814, but the hopyard remained as an adjunct for legend to ripen.

The history of how the hopyard became a public park, however, is easy to trace and can be found all over the web. In 1919, the former State Park and Forest Commission obtained an 860-acre parcel located in the Millington section of Haddam. The principle feature of the park,

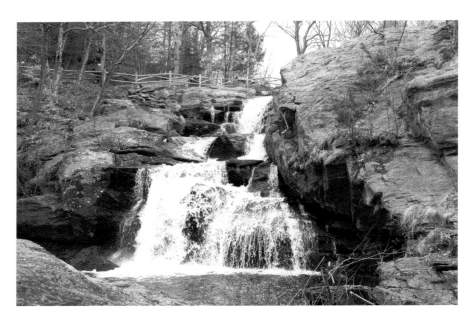

Chapman Falls in Devil's Hopyard State Park, where witches brewed their potions while the devil entertained them with his fiddle.

Chapman Falls, drops more than sixty feet over a series of steps in a Scotland schist stone formation. The falls also once powered Beebe's Mills, which were named after the original owner. The mills operated until the mid-1890s. Today, explorers can take in all the diverse scenery that graces the woodland and even camp overnight near the waterfall—but beware of what lurks behind the trees or in the dark shadows of the rocks, for there is more than meets the eye.

Paranormal investigators have captured EVPs of strange voices and grunts. Equipment has failed to work in the hopyard even though it was tested and in working condition both before entering and after exiting the haunted parcel. Misty figures have been spied moving about the falls by visitors. Many of the local residents attest to seeing apparitions in the woods and hearing unearthly voices rise up out of nowhere and emanate around them. A group of young men were in the park when they encountered a strange, sinister voice that called out to one of them and then began laughing in a most wicked tone. A few of them saw what resembled an inhuman creature sitting on a fence before them. One of the young men was catapulted into the air, hitting a tree. They later found four slash marks that had torn through the leg of his pants. The park is said to house entities beyond our comprehension. There is an account of one person, while roaming the park with family, actually witnessing a large shaggy beast with horns and a face resembling that of a skull.

Legendary horror writer H.P. Lovecraft was inspired by the folklore and tales of Devil's Hopyard. It was the hopyard, among other sites, that gave him the muse for the Dunwich Horror. Real or imagined, the hopyard is full of legends and accounts that make it one of the top places to visit, even if you are just in want of some beautiful natural wonders. It is the place where natural and supernatural seem to meet.

MAKENS BEMONT HOUSE

The Makens Bemont House, also known as the Huguenot House, is nestled between two other historic buildings owned by the Historical Society of East Hartford in Martin Park. The home is bounded on one side by the Burnham Blacksmith Shop (circa 1850) and on the other by the one-room Goodwin Schoolhouse (circa 1820). The two outer buildings are void of spirits, but the Bemont House seems to have some past residents still abiding in the historic abode.

Edmund Bemont purchased the property in 1761, and it was there he built his home. In a strange twist of events, he sold the property a few months later. He then bought it back and turned it over to his son, Makens, the same day. Makens was a prosperous saddle maker, owning one of the very few chaise carriages in town. A chaise is a light, two-wheel carriage with a top that folds down. It could be construed as a colonial convertible. The Bemonts were descendants of Huguenots, French Protestants who had fled other parts of the globe to avoid persecution during the seventeenth century. The name Huguenot House is most likely derived from their religious beliefs. Makens was born in 1743, so he would have been a young man helping to build the home he would eventually own. Makens died on March 5, 1826, and the home was passed on to his wife and subsequently other family members.

The home stayed in the family well into the nineteenth century before it changed hands. Little is written about the property from the period when the Bemonts owned it until just before the Rosenthal family acquired it in the twentieth century. Adolph Rosenthal donated the house to the historical

society in 1968. The society then moved it in 1971 from Tolland Street half a mile down the road to Martin Park at 307 Burnside Avenue. This was when the paranormal activity began to come out of the woodwork.

Renovations were imminent and began like any normal project, but then the "other side" took interest in the work being done. Susan Smitten relates a strange incident in *Ghost Stories of New England* in regard to a certain Herman Marshall who was hired as a restoration consultant. He had locked the door and called the security company to activate the alarms within the vacant structure. The company informed him that they could not initiate the system, as there was someone in the house still hammering away at the interior. Marshall could hear the pounding over the phone that was picked up by a microphone they had set up in the house. He went back to the building to investigate but found it completely empty. Even the operator on the other side was baffled as to how the noises abruptly stopped as Marshall entered the building.

One day, Marshall heard three distinct knocks on the floor coming from the basement. Thinking it was a co-worker needing his attention, he went down into the cellar but found there was no one there. Other workers heard what sounded like hammers banging away in the structure even after they had locked up for the evening. Whatever it was seemed to sound like it was helping out, so the society named the "ghost" Benjamin after the biblical translation, "son of the right hand." Benjamin made a lot of noise but did not move things much. Nor did he really help with the task of restoring the old manor to the splendor now witnessed by those who take a tour of the home.

Other incidents have taken place at the house that are not the work of Benjamin's hands. In 1982, a young girl witnessed a blue dress floating across the lawn near the house. When she looked up to see who it was, she was immediately terrified to see that there was no physical body in the garb that seemed to be floating on its own. It has been speculated that the ghost in the blue dress may be that of Abigail Bemont, wife of Edmund and mother of Makens. Mary Dowden of the Historical Society of East Hartford has had a few encounters with the spirits of the house and talks about them quite candidly. One day she was closing up the house for the season with her mother, Doris. The moment they went out to retrieve the signs, the cool, overcast day poured forth a dismal rain. Both of them suddenly heard a noise from upstairs that sounded exactly like one of the old wooden windows being pulled closed. Neither of them had opened any of the windows, as it was a cold, damp day.

Mary was once giving a tour when the spinning wheel in front of the fireplace began to turn slowly. The wheel made several rotations and then reversed itself a few turns before stopping dead. Before this, the wheel had never as much as rattled in its place.

Witnesses have seen a woman in the second-floor window as well. Some feel it might also be the spirit of Abigail Bemont still watching over her home. The home is a beautifully restored example of eighteenth-century life in New England. Tours are available from June to August. A visit to Martin Park is a wonderful trip back in time where some of the exhibits are still living.

THE OLD HOMESPUN FARM

The old-fashioned charm of the Homespun Farm has transported its guests back to a time when things were just a bit less hectic. The wonderful gardens and antique décor play on the senses in the most pleasing manner. Candlelight breakfasts await the hungry guests, and every room is equipped with a fireplace and full private bath for a serene stay. Ron and Kate Bauer have taken great care in preserving the historical integrity of the bed-and-breakfast—so much so that a few of the original family members still make it their interminable home.

The farm was purchased in 1740 by Simon Brewster, a great-great-grandson of William Brewster, who arrived in the New World in 1620 on the *Mayflower*. For more than two hundred years, the Brewster family ran this historic property as a dairy and orchard establishment. From the handcrafted beds to the hand-hewn beams, what is now Homespun Farm Bed and Breakfast warms you with the spirit of the men and women who worked the farm over the centuries. Members of the Brewster family are buried in the Pachaug Cemetery up the road from the farm. Some are also buried near the property along Palmer Road.

Kate bought the house in 1996 and soon turned it into a bed-and-breakfast, but there were some permanent tenants that would begin to surface. Both Ron and Kate have seen the apparition of a man standing in the orchard out back and mulling around the blueberry patch near the house. They were not sure who the mysterious specter was until two Brewster sisters came to stay at the home. They were in town visiting their mother's grave and

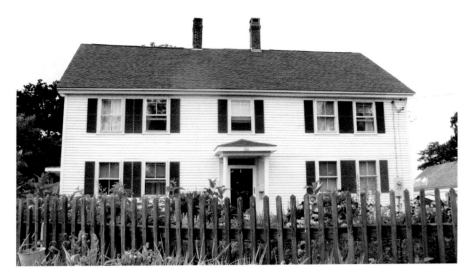

The Homespun Farm in Griswold still tenants members of the Brewster family long after their tenure on earth.

decided to spend the night at their former residence. Kate began telling the sisters about the ghost of a man in work clothes that is still tending the farm. She related that they had witnessed him on several occasions. One of the women went to the car and came back with a photo album. She beckoned Kate to peruse the book, as she might gain some insight on the history of the house. Kate turned a page, and staring her in the face was a picture of the man that haunts the home. It was none other than Simon Brewster. On the next page was Simon's father, who bore a striking resemblance to the ghost as well. Neither Ron nor Kate can be sure which Brewster actually haunts the home. Perhaps it is both. They are sure of one thing: the Brewster family, although buried in the nearby Pachaug Cemetery, have never left the Homespun Farm.

The whole Bauer family has heard footsteps going up the back stairs and down the front stairs. They have deduced that it might be Mrs. Brewster still rambling through the household. There are three guest rooms—the Cherry Room, the Orchard Room and the Sunset Room. A guest took a photo in the Cherry Room, which used to be Mrs. Brewster's bedroom, and captured a white misty light that might just be the revenant of the former matriarch of the house.

The orchard where the ghost of Simon Brewster has been seen wandering among the trees.

Another strange occurrence relates to a number of old-fashioned bobby pins that Kate found around the house, particularly near the back stairs. Kate was a perfectionist in her quest to keep the Homespun clean for visitors. "There is no way I could miss these pins in the middle of the floor while vacuuming," she said. She put the pins in a glass case in the kitchen that showcases the many other artifacts of historical value found about the property. While she was telling this strange tale to someone else, she opened the case to show her guest the bobby pins and they were gone. Everything else was where it should be except the pins. She emptied all the shelves, yet not a single pin could be found.

Kate's aunt was convalescing at the Homespun with aid from a hospice nurse. One day, the nurse just happened to mention that she used to care for Mrs. Brewster when the elderly woman still lived in the house. When the nurse was done with her duties, Kate asked if Mrs. Brewster had long hair that she had to pin up. "You don't know," said the nurse. "It took me three hours to do her hair. That's how long it was. You can't imagine how many bobby pins I had to put in her hair to hold it up." Kate later found out that Mrs. Brewster had passed away shortly before her guest had inquired about the pins. Kate figured that perhaps Mrs. Brewster came back to claim her bobby pins.

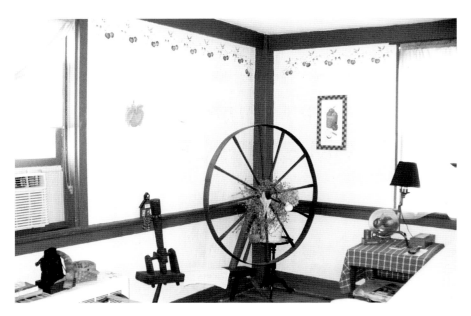

Mrs. Brewster's former room, where a guest captured a ghost on film.

At present, the Homespun is closed for guests, but it can be assured that Mr. Brewster still watches over the owners as they tend the blueberry bushes or while they work in the orchard. He is by no means harmful, just very attached to the place he loved in life. The Bauer family has kept the homespun charm at the home the Brewer clan knew in life, so it can be assured that they must be elated in the afterlife as well.

The farm is presently for sale. No further information is available as of this writing.

Fort Griswold's
Gruesome Ghosts

During the War for Independence, many fortifications were erected on hills and ledges along the coastline to protect the towns from British invasion. New London Harbor was home to many privateer ships commissioned by the State of Connecticut to raid and capture enemy vessels. Fort Griswold was erected to protect the harbor, ships, town and British spoils taken by these privateer vessels. On September 6, 1781, British Regulars invaded Groton and New London under the leadership of Benedict Arnold. The first order was to burn down the home of Thomas Mumford, who for some reason had gotten on the wrong side of the British general. Then the rest of the town was to follow. In all, seventy-five dwellings, thirty-seven stores, eighteen mechanics' shops, twenty barns and nine public buildings were set ablaze. Most of New London made for quite a conflagration. Arnold then ordered Lieutenant Colonel Eyre and his eight hundred troops to take the fort on the Groton shore.

Upon reaching the fort, Eyre honorably sent a flag forward demanding a peaceful surrender, but both times it was refused. Continental army colonel William Ledyard was convinced that reinforcements were on the way and challenged the British troops despite the proclamation that no quarter would be given if the fort were to be stormed.

The first barrage of fighting proved lethal for the British, as many were killed and wounded trying to cross the deep ditch in front of the garrison. The endless barrage of attacks paid off, and soon the British were able to

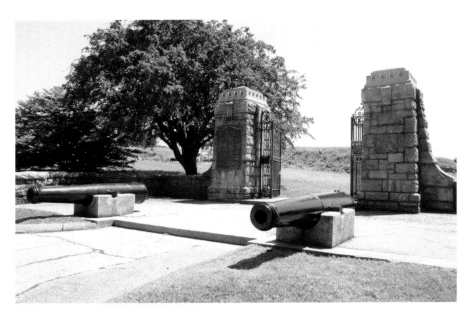

The entrance to Fort Griswold State Park in Groton.

infiltrate the fortress to the point where they actually opened the gates and marched in.

Colonel Ledyard and his men were outnumbered by more than four to one as his 150 men made a futile attempt to hold off the 800 British soldiers who stormed the fort. Within forty minutes of fighting, Colonel Ledyard was forced to surrender. The actual casualty count has been blurred over the years, but it seems the British, though victorious, took a licking as well. According to records, 85 American soldiers were killed and the rest wounded. When Colonel Ledyard presented his sword to Captain Bloomfield in the usual gesture of honorable concession, the captain turned the sword on him, killing him on the spot. At this point, the British reportedly killed most of the prisoners, and shots once again volleyed back and forth. The British then loaded an artillery cart with the wounded so they could blow up the magazine within the fort. While moving the soldiers to safety, the artillery cart full of wounded Americans broke away from its carriers and reeled down a hill, crashing into a cluster of trees. The American version of the story was that the cart was purposely sent reeling down the hill. The impact was so brutal that the cries of the wounded could be heard across the river. Some died on the spot. The rest of the prisoners were taken to the infamous

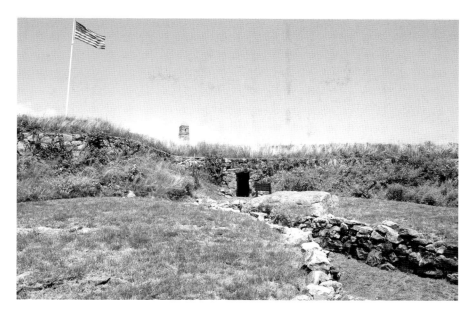

The remains of Fort Griswold still echo with those who lost their lives for the cause of freedom.

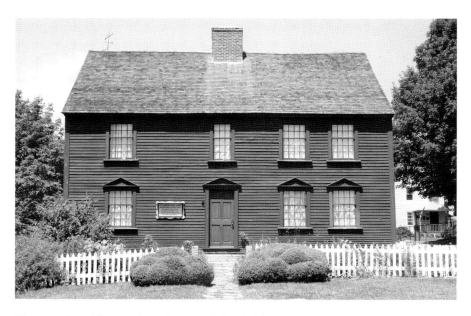

Ebenezer Avery House, where the wounded and dying were taken after the massacre.

British prisoner ships, where disease and death ran rampant. Locals later took the wounded who still showed signs of life to the Ebenezer Avery House to nurse them back to health. The house, with its colonial garden, sits at the bottom of the hill just beyond the fortress. The actual sword of Colonel William Ledyard is on display at the fort museum.

All of the dead, both British and Revolutionaries, were buried in a mass grave at the gates of the fort so hastily that many of them were barely covered by the soil. In the end, the British lost fifty-one men to the eighty-five suffered by the American side.

Today, the fort, along with the Ebenezer Avery House, is a museum and tourist site where people can visit and experience for themselves a bit of the past, for in some cases, a bit of the past still lingers within its walls. Paranormal groups have recorded EVPs, or ghost voices, in the fort. The voices speak in an old English dialect, which would be normal for either side in the era the battle took place. People have taken photos of strange orbs and mist in the fort, suggesting that a strong source of energy still lingers within. *Haunted Times* magazine, along with New England Paranormal Research Agency and Atlantic Coast Paranormal Research Group, captured a face on film in the Avery House. In the staff headquarters, they caught the voice of a little girl reciting her ABCs. They recorded a lot of "No" answers to their questions, suggesting that the energy there was intelligent and aware of their presence.

There is a monument dedicated in 1830 that stretches 134 feet into the air marking the site of Connecticut's most famous Revolutionary War battle. It is inscribed with the names of the eighty-five soldiers who gave their life for the cause of freedom. There is also a memorial plaque on the spot where Colonel Ledyard fell by his own sword.

It seems the ghostly voices of the fort still permeate the air to this day. They obviously have something to say about the brutal battle that took place so long ago. Perhaps, for history's sake, we should listen.

THE HEADLESS HORSEMAN
OF CANTON

The quaint hamlet of Canton was once part of Simsbury before becoming a separate town in 1806. The town's dimensions run about eight miles north to south and four miles east to west. What is now Canton Village was once known as Suffrage, and it was in this village that a most bizarre and gruesome account took place. The reader of this narrative may rebuke its contents, but there is proof of what is penned, not only here but in historical tomes as well. The idea of a headless horseman brings up childhood memories of reading tales of horror around Halloween or even the great writing of Washington Irving. Perhaps there is also a lace of truth woven into his tale about the famous headless horseman.

During my research into this amazing legend, I came across an article written by Canton historian Dr. Lawrence S. Carlton. It is with his kind permission that I reprint his work for all to enjoy, as no one seems to have recollected it better than he. It is called "The French Paymaster's Ghost."

It is late fall in the aftermath of the American Civil War and a weary traveler urges his horse through a narrow defile by the eastern border of the town of Canton, Connecticut. The slight breeze with just a hint of the approaching freezing gales of winter swirls gray fog about the base of the rocky cliffs. Ill-defined shapes resembling weird four-legged creatures or heavily cloaked predators of malevolent design appear and disappear before the traveler's eyes, sometimes dead ahead but more often just on the fringes of his range of vision. He digs his heels into the horse's flanks as he feels

impelled to move quickly between piles of rough boulders fallen from the cliff heights. Suddenly his steed stops with ears pointed straight forward, but no sound is heard. Yet there, just off the worn path of the road, there is someone faintly descried sitting astride an equally faint image of a horse.

The traveler calls out a greeting, "Can you tell me how far it is to Hosford's Inn?" No answer is forthcoming. Instead, the figure raises his hand pointing ahead and gallops off and disappears to the west. It is only then that the traveler feels a cold chill along his spine as he realizes that his guide, not only makes no noise in his leaving, but is without a head on his shoulders.

Considerably shaken by this apparition, the traveler pushes on and shortly arrives at the famous Hosford Stand, a noted rest stop on the old Albany Turnpike between Hartford and upstate New York. Here the bartender notices the new arrival's shaking hand as he grasps his pint of ale, and gazing at his wan face remarks, "So, you've seen him, too! The French paymaster! Conditions must be right this evening. Have a seat and we'll tell you about him."

The locally well-known tale begins in the year 1781, during the waning years of the American Revolution. A young lieutenant of the allied French forces, on his way to bring much-desired monetary payments for his comrades along the Hudson River in the neighborhood of Saratoga, stopped for the night at this inn. In those days it was Dudley Case's Tavern, one of several hostelries along the then poorly-traveled Albany road. Several of the local fellows in the taproom having their customary late evening bitters noted the arrival of the well-dressed officer and the heavy leather saddlebags thrown over his shoulder. The lieutenant responded to their inquisitive comments by indicating that he spoke little English and merely asked for food and a private room for the night. After his meal he followed the innkeeper upstairs to a room and, asking to be awakened early in the morning, entered the room, closed and locked the door.

Except for the innkeeper, who alleged to have awakened his guest early and sped him on his way, no one ever saw the paymaster again—at least not in the flesh. A month or two later French and American officers visited the Case Tavern with many questions about the paymaster's disappearance, for, indeed, he had never reached his destination, nor had he been seen at any other inns along the route. No trace was found at that time; however years later some boys fishing in nearby Cherry Pond did pull up some fragments of an old saddle and remains of a long-dead horse, which had unique horseshoes on its deteriorating hooves. Also, it was said that a half-

wit who worked at the inn had been heard to remark, "I shook the bush but somebody else got the birds." In his last days on earth the dying man was closely guarded so that no curious inquisitor could get near enough to hear his ravings. Since that time, especially on moonless and foggy nights, a ghostly rider, sometimes without a visible head, speeds along the pike heading west. The apparition is believed to be the ghost of the French paymaster, murdered at or near this place in 1781 and unable to complete his urgent mission.

Our traveler, after a restless and nearly sleepless night went on his way, but never forgot his eerie experience. Several years later he learned that the Hosford Stand had burned to the ground in 1874 and that workers cleaning up the site had stumbled on a skeleton partially buried in the cellar floor of the inn along with a few ragged fragments of leather. Curiously the skull was found separated at some distance from the remainder of the bones. Folks then recalled that the innkeeper seemed to continue to be prosperous, buying new furniture and other things despite the fact that his business had greatly diminished.

In recent years no sightings of the headless paymaster have been reported. Perhaps the endless motor traffic along a widened and paved highway has finally put an end to these apparitions. Nevertheless, the legend lingers on.

Lawrence S. Carlton, MD

For many years, witnesses encountered the phantom racing at a furious clip on his steed, whose eyes glowed with the fires of hell as its hooves pounded the ground, yet no sound could be heard.

In contrast to the above writing, motorists traveling along that section of Route 44 have attested to seeing the phantom horseman gain upon them with shocking speed. According to other sources and stories, with the advent of the motorcar, drivers were often taken by surprise by the ghastly specter as it came out of the shadows and caused them to swerve in an attempt to avoid a collision. To this day, motorists still report the sudden appearance of a headless misty figure on horseback heading west on the turnpike in the small hours of the night. Many have had to turn suddenly to avoid hitting the phantom rider, who seems to be forever trying to complete the task of delivering the pay to his fellow soldiers.

Could it be an overactive imagination, or perhaps a bit of weariness on the part of drivers as they wisp by the shadows along the road? I cannot say either way, as I have never come across the eternal rider, but someday, by chance, you possibly will.

The Albany Turnpike is better known as Route 44, a thoroughfare that stretches from Plymouth, Massachusetts, cutting its way through Rhode Island and Connecticut and finally entering New York State. There is no shortage of haunts along this highway. From phantom hitchhikers to ghostly riders, Route 44 boasts them all.

GAY CITY STATE PARK

It is difficult to imagine that Gay City State Park was once a fully populated community of twenty-five families, a woolen mill, a satinet mill, two gristmills, charcoal pits, a church, a general store and other such amenities that could be found in the small hamlets that dotted the New England landscape at the time. Other than stone walls and foundations, there is not much evidence left to show that settlers once called the place their home. There are also the ghosts that occasionally remind explorers visiting the old town that not only were they once residents in the flesh, but they are eternally tenanted there in spirit. A small burial ground near the entrance of the park contains a few members of founding families that lie in repose. The stones are placed on either side of the burying yard facing each other. This lends credence to what history tells us about the two prominent families of Gay City and the differences they had toward one another.

The original name for the village was Factory Hollow. A preacher named Elijah Andrus steered his congregation toward the wooded hollow in 1796. The northwest region of Hebron had been adequately settled about one hundred years prior, but the Methodist minister was dead set on starting his own community for himself and his followers. One must remember that early New England towns were dominated by religion. In fact, many towns were either annexed or completely disbanded due to the lack of a meetinghouse being within an acceptable traveling distance. Religion was a main staple in the community, and Factory Hollow was no exception to that rule.

Andrus suddenly abandoned his flock four years later due to disagreements and quarrels within the congregation. This left Reverend Henry P. Sumner as the new spiritual leader of the village. His grave is among the scant stones in the burying ground near the entrance of the park. Also in 1800, John Gay was chosen to head the new town's affairs. A major portion of the hollow was composed of the Gay family, so it seemed logical that they would have a majority of the say in town affairs. John's brother Ichabod also shared the responsibility of leadership, along with Reverend Sumner. This union did not work out as well as everyone thought it might. The two families had already been at odds with each other from the start, and matters only got worse with time.

Reverend Sumner held church services twice a week, which to some was a bit too taxing on their time. To augment the attendance, rum was given to the men to quaff. It can be assured that the meetings had "spirit" to them, but the libations would prove to be the downfall of the sermons. Arguments and even fistfights became common during the meetings, so much so that many of the families began migrating away from the town, including several of the founding families.

With only eight years under their roofs, it appeared that the little hamlet was about to become a ghost town. In 1810, a woolen mill opened under the name of William Strong and Company. The town was flourishing, but another dark cloud would cloak prosperity. The War of 1812 between the United States and Britain broke out, and British blockades halted commerce, forcing the mill to close its doors. According to J.R. Cole's *The History of Tolland County, CT*, Reverend Sumner took ownership of the mill until 1830. He ran it as the Lafayette Manufacturing Company until a dreadful conflagration reduced the building to a stone foundation. At this point, families packed their belongings and moved into cities to work in the larger factories.

Dr. Charles Sumner, son of Henry Sumner, decided to erect another mill near the site of the old one. This time it was for the production of rag paper. Residents, along with laborers from nearby towns, began the arduous task of transporting stones for the foundation. A dam and beautiful stonework canal were created to power the overshot wheel that would turn not only the machines in the mill but the fate of the town. Unfortunately, the powers of the dark side did not wait very long to taint the massive undertaking.

During the construction of the dam and canal, one worker studied the angle of the duct and concluded that the water was supernaturally flowing uphill toward the factory. He is reported to have dropped his tools and quit on

the spot, calling the phenomenon the work of the devil. Others would follow in his wake, bringing the construction of the venture to a temporary halt.

Finally, the mill opened, and Factory Hollow saw a slight incline in prosperity. But another struggle, the Civil War, would again play fate in the village. Many of the young men in town enlisted in the army. Most of these citizens were killed in the war, leaving a number of homes in Factory Hollow unoccupied and crumbling until a time when the elements of nature reclaimed the land. The paper mill burned in 1879, leaving the last vestige of the hamlet to the elements. Before long, trees and brush sprouted from the decaying cellar holes and foundations. Truman Porter was the last known resident of Factory Hollow. He, too, soon passed on, and Factory Hollow was no more.

For the most part, Factory Hollow was now a true ghost town. Visitors to the site frequently found buttons near the ruins of the old factory building that came from the cloth rags used in making the paper that the mill produced. The last Sumner born in Factory Hollow was John Sumner. His son George became lieutenant governor of Connecticut, serving from 1883 to 1885.

A plethora of notable citizens hailed from what is now known as a ghost town. Charles Kellog Gay married Polly Whaley, who claimed to be a direct

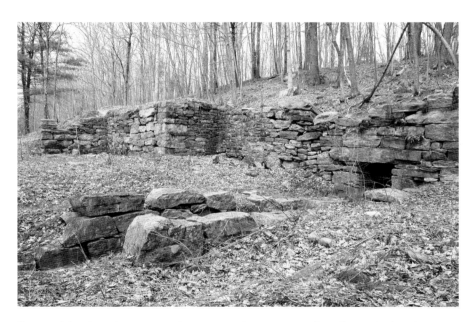

Strange things have been reported to occur at these remains of the factory in Gay City State Park.

descendant of the famous Sir Edward Whaley. F. Haldiman Sumner was an aide to General Johnson during the Battle of New Orleans in 1815; Dr. Cyrus Sumner was a well-respected surgeon in the War of 1812; Frank Sumner was the president of the Hartford, Connecticut Trust Company; and Colonel Benjamin Sumner commanded a regiment in the War of 1812. Another noted character of Factory Hollow was a preacher named Samuel Peters, a devoted Tory faithful to the throne of King George. A group called Sons of Liberty made him sign a declaration of repentance or lose his possessions. He moved to England shortly after, where he published *A General History of Connecticut.* Needless to say, it was a very one-sided view of the colonists' life in Connecticut. He claimed that the pompous people of his former home "outpoped the pope and outking'd the king."

Emma P. Foster and her sister Alice acquired most of the overgrown ghost town, including two thousand acres owned by Dr. Sumner. The Fosters were descendants of the Gay family. The old town became a state park in 1944 by will of the sisters. Most of the Sumner graves were moved to Gilead Hill Cemetery down the road. In 1953, the state appropriated twenty thousand more acres for further development of the park. The name Gay City State Park came by a request from none other than a descendant of the Sumner family. This act suggests that the two families may have long buried the hatchet and found eternal resolution to their differences.

The spirits of the park do not have eternal resolution. Stories and reports flourish to this day of ghostly encounters and unseen forces that wander among the living who visit the haunted hamlet. There are two accounts of murders that took place in the old town during the previous centuries that may explain some of the ghosts that wander among the thicket.

Just before the Civil War, a jewelry peddler came rolling into town on his usual route. Peddlers were common in those days and sold everything from tinware to top hats. Some even took to "tinkering," or repairs, to augment their incomes. The salesman suddenly disappeared without a trace. Shortly after his disappearance, a human skeleton was discovered in one of the charcoal pits at the edge of town. Evidently the purveyor of goods had a healthy sum of money on him that attracted the attention of some unsavory kind. No clues as to who was responsible for the crime ever turned up, and to this day, the murder remains unsolved. The peddler's ghost, as if seeking justice for his untimely demise, now roams the perimeter of the little hamlet. More than a few visitors have stumbled upon the old charcoal pit, where they have witnessed the ghastly sight of a glowing skeleton hovering just above the ground. The spectral skeleton is

not the only permanent phantom of the old village. The spirit of a young man wanders among the thicket eternally trying to appease his employer centuries after they have both turned to dust.

A teenage boy became apprentice to the local blacksmith in hopes of someday becoming his successor. The blacksmith was a gruff, short-tempered man with not much patience for insubordination, but he took on the role as teacher to the young man. One day the apprentice decided he was going to take the long way to the shop, stopping and enjoying the morning every chance he could. When he arrived at the forge, the blacksmith, having expected him to arrive at work on time, was steaming with rage. No one knows what exact words may have been exchanged, but the blacksmith lost his temper and hacked the boy to pieces with a butcher knife. Legend has it that he even lopped the poor soul's head off. The blacksmith was never brought up on charges, and the ghost of the apprentice now wanders among the woods, hastily making his way to some unknown destination, perhaps for fear of being tardy. Some have seen him running with his bloody head cradled under his arm.

Paranormal investigator and reporter Lauren Neslusen paid a visit to Gay City State Park in the winter to see if the legends of the haunts held any weight. Here is what she told me.

> When I was investigating there I saw and heard some very weird things. The strangest thing I saw was a black mist that disappeared quickly off to the side of a trail. The best way to describe it was about four feet off the ground and maybe three feet wide. It was solid in the middle but seemed transparent around the edges. The second weirdest thing was the other investigator and I were exploring the old mill site and rocks and debris kept falling from the top of the wall to the ground. (Almost as if someone was standing there.) We went in the middle of winter while the ground was still frozen so I don't think it could have been the ground thawing or anything. I took some EVPs at the site but nothing came up on the recorder. As we were walking up to the pond though, we did hear distinct voices coming from the mill site. We ran back but found no one. We even called out and no one answered. The last thing I wanted to mention was we did hear something walking in the woods (you could hear crunching in the snow) but we saw no animal and no people; it was just very strange.

What was the strange black mist? It may have been one of the ghosts of the park or another anomaly that is yet to be explained. Arlene and I paid a

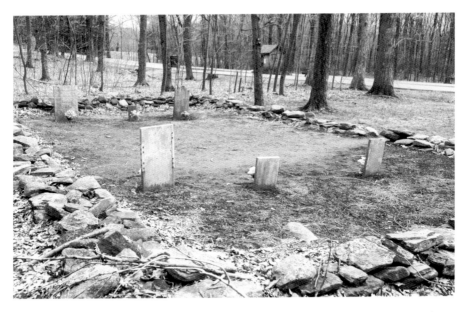

The cemetery where a few members of the Sumner and the Gay families rest on opposite sides in Gay City State Park.

few visits to Gay City and found it to be a fascinating place where the locals love to walk their dogs and hike the trails.

We decided to hold our first vigil at the small graveyard. Using dowsing rods, tarot cards, an EMF detector, a camera and a digital recorder, we began to read the cards and work the rods in hopes of fielding questions about some personal history of the people who still tenant the town. We use these instruments merely to field questions that may be pertinent to the history of a place on both the personal level of those whose energies may still linger and the area as a whole. We have achieved astonishing results in the form of both audio and perceptive evidence. Although we must admit that the perceptive part would classify as more of a personal experience, the audio EVPs are much more tangible.

We then made our way to the factory ruins, where we continued our quest to find more answers about the rise and demise of Factory Hollow. Arlene is a gifted reader and dowser who credits the results obtained to the surrounding atmosphere. She states that we are just an instrument in the process of communication and does not portend to be psychic. Her powerful aura always manages to draw the living to her. Why not the spirit energy as well?

We came up with a few interesting results in regards to the cards. The readings and dowsing rods must have stirred up some lingering energies, as we found that on both accounts, there was someone who had gone from prominence to poverty at both places and someone who had felt sad about the state of the town. As for the recorders, the ambient noise made it hard to obtain any real conclusive results short of the spirits shouting in our faces.

Based on our visits and the testimony of many who have witnessed the haunted happenings at the park, it is safe to conclude that although we see it as a ghost town, the other side still sees it as alive to some degree.

TORY DEN

Tory Den holds many dark secrets that have unfortunately been diluted over the passing of time. The stories themselves are but vague recollections of local legends mostly forgotten due to the lack of oral tradition. Enough of the tales, however, have been saved for those who might desire to dip into the proverbial jar of poetic license and narrate embellishments of the place based on remaining folklore and history. There are two things that are certain: one, the place was a frequent stop for the legendary Leather Man; and two, the locale is haunted by some unknown entities that have etched their place in the history of the den.

The name of the den is derived from the moniker given to British sympathizers of the Revolutionary War. There are several Tory caves in Connecticut, but most of them are located in Litchfield County. Many of the colonists sided with the throne of England during the struggle for freedom. These colonists believed that England was much too powerful to ever cede to a ragtag group of revolutionaries. Some even fought against their own neighbors in their belief that the king would always be their ruler. During the struggle, it is said that some of these Tories deserted their homes and ranks and sought shelter in the caves in attempts to escape the wrath of the enraged and vengeful insurgents. The harsh New England winters brought woe upon them, and many perished, perhaps leaving their resentful spirits behind to taunt those who venture into their hideaways.

The most famous Tory Den is located within the Mile of Ledges and the Tory Den Trail in the southwest corner of Burlington on the Bristol

border. During the time of the Revolution, parts of Bristol, Burlington, Harwinton and Plymouth were heavily populated with British Loyalists. The colonies feared that these Loyalists were a great danger to the success of their cause and therefore sought to eradicate them from the land. When the Tories were captured, the revolutionaries would use various means to either punish them or convert them to their side for the cause of freedom. Seventeen Loyalists were rounded up and examined at the home of David Bull on May 22, 1777, by a special committee of the General Assembly in Hartford. These were British sympathizers from the New Britain area who were found to be under the heavy influence of a certain Reverend James Nichols, a Yale graduate and minister. Nichols had been tried by the Superior Court in Hartford on January 27, 1777, for treasonable practices but had been acquitted. Nichols was subject to tar and feathering and was reported shot at several times. He then sold his farm and moved. It is written by E.L. Pond in *The Tories of Chippeny Hill* that he died miserably on June 17, 1829, at the home of one of his sons in New York at the age of eighty-one.

The Tories tended their farms in numbers for protection. If a solitary Tory was in danger, it was customary for him to flee to the secret cave for protection. The women of the families were sentinels who held an ever-watchful vigil for Tory hunters or members of the Continental army. When such adversaries were spied, the women would blow either a horn or conch shell, thus signaling for the men to retreat to the cave. It is reported that multiple attempts to locate the cave were made in vain by the frustrated Sons of Liberty. Two young boys, Bela A. Whelton and X.A. Whelton, the latter a grandson of Stephen Graves, discovered the den in 1838. Graves, a devoted Loyalist, had a log cabin less than a mile from the shelter. It is written that he and his colleagues hid in the cave on many occasions and his wife stole away in the thick of night to bring them food.

A massive slab of rock that fell from above, landing on two other wedges that supported the stone, created the natural chamber. The southeast entrance is ten feet wide and five feet high. The interior is the same width but rises to six feet in height. There is a small opening in the center of the thirty-five-foot-long den where a person can pass through. This may have been used as a chimney for small, discreet fires that kept the hideout somewhat warm in the colder months. Most often, however, they likely had to endure the unsavory New England weather without the comfort of a fire, as the smoke may have been spied by the pursuant. The north face entrance is only four feet high and five feet wide.

Present-day campers and hikers still hear the voices and heavy breathing of the British Loyalists who have long dropped their arms yet still prowl among the living. Some have felt a heavy, fearful presence when visiting the shelter. Misty figures seem to hover around the cave as if holding an eternal vigil in the hopes of remaining elusive to those they are hiding from. Perhaps one of them is the ghost of Moses Dunbar, the only known Loyalist to be hanged for treason during the Revolution. Dunbar lived in a place then known as Chippeny Hill in the Bristol/Farmington area. He was tried at the same time as Reverend Nichols, but he was not so fortunate. Dunbar, born June 14, 1746, swung from the gallows in Hartford on March 19, 1777, at the age of thirty. It is written by Pond that Moses's father and ardent revolutionary Patriot Sergeant John Dunbar actually offered to furnish the hemp to hang his son.

Strange lights have also been spied around the caves, but upon examination there is no human present to perpetuate them. Visitors to the den have also reported hearing the rhythm of drumbeats. These ethereal poundings can be heard along the blue trail in the den. Their origin remains a mystery. Some have even reported the wraith of the famous Leather Man near the grotto he used as a shelter during his route around western Connecticut. He is, according to legend, known to still frequent or protect the caves he made regular slumber stops at from 1858 to 1889.

NINEVEH FALLS

The legends and ghost stories of Killingworth rival many other towns that proclaim their land to be tainted with the supernatural. The area has an interesting historical account as to its settling by the white man. The Hammonasset were a peaceful tribe that lived along the shores between the Agiciomock River and the Connecticut River. Their sachem was known as Sebaquanch, "the man that weeps." Uncas, the famous Mohegan sachem, married his daughter, thus inheriting the Hammonasset land. He then sold a generous parcel of real estate to George Fenwick, Esq., of Saybrook. On November 26, 1669, Uncas sold the rest of the land to the residents of Killingworth. The remains of an Indian village are located about half a mile north of Route 80 near the junction of Roast Meat Hill Road and Wolf Meadow Road (even the names of the roads provoke historical queries as to their origins). The village consists of several rock shelters where Indian artifacts have been discovered. A place called Nineveh Falls sits not too far from the village within the Killingworth Land Conservation Trust near Lake Hammonasset. The area has gone through many changes over the eras, but the legends never fade. Indian spirits, witches and eternal love are some of the ingredients in the following small but potent narrative. Special thanks go to Killingworth head librarian Tammy Eustis for supplying as much accurate information concerning the legends and haunts of Nineveh Falls as was available. It is with great excitement that I now relate these accounts that have made the falls one of the must-see places in Connecticut.

The falls have a haunting legend concerning an Indian maiden who was given false news on the fate of her lover. Her betrothed was a warrior who went to battle with a promise of marrying her upon his return. Sometime after his departure, false news arrived of his death during combat. Heartbroken and distraught over the loss of her beloved, she made her way to the falls and, in a state of depression and sorrow, threw herself into the rapids. The brave returned to find that his lover had leapt to her death. Feeling there was nothing else to live for, he decided to join her and jumped into the same rapids as she. Now, when the full moon casts a blanket of light upon the land, witnesses can see two ghostly figures walking along the edge of the falls, hand in hand in eternal wedlock.

There is another forlorn tale of a beautiful young woman who fell in love with a local farm boy. The young farmer was not only the sole provider and caretaker of the farm but also was engrossed in the undertaking of looking after his aging mother. The story takes two turns from here. One is that the woman, though infatuated with the young man, knew she would never entice him away from his mother and thus traversed the rocks to the cliffs of the falls and shot herself in the heart, falling into the torrents at the base of the falls. The next version is what the old-timers will tell you when sitting around the country store potbellied stove on a bitter winter afternoon. In this version, the young man did not care for the girl and resisted her affections for him. This caused the jilted lover to throw herself from the cliff into the rapids below. Either way, the result was the same, and the place has become known as Lover's Leap.

Another legend associated with the area involves one of the early settlers' most feared entities: witches. Yes, even Killingworth has a history of those who were in league with the devil. These old hags were said to frequent the Nineveh and Chatfield Hollow areas, brewing their concoctions and casting spells on unsuspecting undertakers passing by the wicked realm where they held consort with the most evil one. Two of these hags were Goody Wee and her daughter Betty Wee, who traveled back and forth from Killingworth to North Madison casting their spells on people for goods and profit. In a nineteenth-century book called *The History of Middlesex County*, neighbors claimed that the Wee witches had the power to enter their homes and curdle their finest cream so it could not be churned into butter. Not a single villager had any misgivings that witches skulked about within the dark bowers of the river's edge. It is written that no farmer could pass by these malevolent hags without an assessment of goods from their carts. If they refused, the carts would mysteriously topple and all of their cargo would be lost.

Ghosts also lurk in the woods around the falls. Who they actually are is probably forever lost to antiquity, but they have been blamed for many odious occurrences that have taken place in the area over the centuries. One such tragedy took place at the end of the nineteenth century when a woman was approaching the falls in her horse-drawn chaise. Something supernatural suddenly spooked the steed, and he started bucking furiously before breaking into a sprint down the hill toward the bridge. The woman tried to pull the reins and halt the horse, but to no avail. With fire in the animal's eyes and fear in his heart, he dashed straight through the wooden railing and off the bridge, sending surrey and all into the river below. Needless to say, the woman and her mare did not survive the "ghostly" encounter.

Tom Lenz, town historian, published a book called *A Photographic History of Killingworth*, in which some of the old photos and stories regarding the legends have been preserved for future generations to savor. If you decide to visit the falls, do not attempt to do so in the snow or ice, as the paths are steep and treacherous.

Nineveh Falls can be viewed from Route 80 in Killingworth for those who wish not to traverse the trails.

The Black Dog of the Hanging Hills

Just the name "Hanging Hills" evokes trepidation as to what lies within the rocky crags of Meriden's natural wonder. Do not let the name fool you—the Hanging Hills provide breathtaking vistas of the surrounding area. The East Peak is located in the 1,800-acre Hubbard Park, where adventurers can ascend to the top of a stone tower called Castle Craig for a better view of the New England landscape. On a clear day, hikers can see the foothills of the Berkshires and Mount Tom to the north, and Long Island Sound as well as the Sleeping Giant Mountain Range to the south. The 32-foot-high tower was built in 1900 and stands at an elevation of 976 feet above sea level. Walter Hubbard had the tower built, but as to what inspiration the world traveler drew from has been lost to antiquity.

The area known as the Hanging Hills and Lamentation Mountain were formed by volcanic action about 200 million years ago when the dinosaurs ruled the land. Lava flowing into the valley cooled and hardened into an igneous rock called basalt. The park and surrounding area is truly a magnificent place to visit, but like many other places in Connecticut, there is a supernatural side that lingers within the very heart of the hills. This supernatural entity comes in the form of a friendly black dog.

Unlike the black dog of Great Britain called the Black Shuck or the Snarly Yow that terrorizes the South Mountain area of Maryland, the Black Dog of Meriden is rather small in size and affable. The former two spectral animals are seen as very large and hairy with blazing red eyes and fierce fangs protruding from their snarling snouts. Although the Snarly Yow is not

considered a death omen, the Black Shuck is certainly a sight one never wants to behold, for surely death will unveil its wrath upon the beholder. The Black Dog of the Hanging Hills seems to fall somewhere in between these two creatures of the unnatural world.

The Black Dog leaves no paw prints in either snow or sand. It makes no sound, even when it appears to be barking or howling. Witnesses attest to having seen a misty vapor emanating from its mouth, but otherwise it just moves silently along the trails and paths of the hills. According to history and legend, if the Black Dog visits you for the first time, you will experience great joy and abundance in your life. The second time you come into contact with the visage, you will experience sorrow, and the third time death is close behind.

The legend of the Black Dog goes at least as far back as 1898, when geologist and Harvard student W.H.C. Pynchon sought to study the Hanging Hills' geological marvels. While surveying the mountain called the West Peak, he noticed a moderate-sized black pooch following him. The creature kept its distance yet never strayed from Pynchon's view, and Pynchon admitted later that he greatly enjoyed the company of his newfound friend. When the young geologist turned to head toward home, the dog looked back once and then vanished into the woods.

Three years later, Pynchon returned to the West Peak with a friend and colleague, Herbert Marshall. Marshall was a geologist with the newly formed United States Geological Survey. Marshall had orated to Pynchon the fact that he had seen the same dog not only once but twice before while studying the geological treasures that abound in the Hanging Hills. As for the legend, he thought it to be just that and nothing more.

The next morning, despite the bitter cold and snow, the two ascended the south face of the West Peak. As they reached the deep fissures in the cliffs, Pynchon made reference to the formations resembling what he pictured as the biblical valley of the shadow of death. His pondering was abruptly interrupted by the sudden halt in Marshall's stride. There on the rocks above them was a black dog. It was now the second sighting for Pynchon but Marshall's third.

Pynchon would soon come to say, "We saw his breath steaming from his jaws, but no sound came through the biting air. Marshall turned and uttered, 'I did not believe it before, I believe it now.' And then, even as he spoke, the fragment of rock on which he stood slipped. There was a cry, a rattle of fragments falling—and I stood alone." Rescuers would later find Marshall's body in the ravine, along with the visage of the macabre Black Dog standing sentinel high above.

The death of his friend and the chance of seeing the ominous canine for the third time was not enough to keep the ardent geologist from completing his studies of the West Peak. He knew that he was doomed when he wrote these words: "I must die sometime. When I am gone, this paper may be of interest to those who remain, for, in throwing light on the manner of my death, it will also throw light on the end of the many victims that the old volcanic hills have claimed."

Six years later, the brave geologist set out to further study the hills. He never came back. His frozen body was found several weeks later in the same spot where his friend Marshall had fallen to his death several years earlier. He was the fifth person in thirty years to meet his fate in the Hanging Hills. Whether his death was the result of the perils of the range or the third time he saw the ominous beast is a mystery that may never be solved.

Some claim that the Black Dog still roams the vicinity of the Hanging Hills. Other incidents and tragedies are attributed to the ghostly beast's presence in the hills. Another account tells of two friends who chose to hike the hills for a weekend. One of them chose to scout out the territory during a rainstorm while the other wisely decided to stay dry and comfortable in the rented room. The dog appeared to the hiker and was friendly enough to have the trekker assume it was a neighboring pet. After all, how could such a pleasant creature be an animal of ill omen? When he returned, he told his story to his friend, who mocked him in regard to the legend.

The next day when they returned to the mountain, there was the black dog again, as on the day before. It was the man's second sighting. Just as he pointed the phantom out, his footing gave way and he fell, breaking his leg. Both hikers concluded that it would be best to never stray onto the range again, for they now held stock in the legend of the Black Dog of the Hanging Hills. The park is a beautiful place to visit, but if a black shadow emerges from the trees, seeing it once is all right but the second or third times are not recommended.

CHARLES ISLAND

C harles Island is a place inhabited by haunts from all sorts of categories. Ghosts of pirates, monks, Indians and flying demon skeletons are just a few of the many eerie, ethereal beings that inhabit the small island off the shore of the Silver Sands State Beach. The place has a long and mysterious history that keeps some coming back and others from venturing even close to the cursed islet. A causeway that appears during low tide secures the adventurous access to the haunted island. That is when beachgoers take to the outcropping for some sun and fun and, perhaps, a chance meeting with the resident ghosts.

The island had long been used as a summer retreat for the Paugussett Indians and sachem Ansantawae. The land was considered by the tribe to be holy ground, and the privacy assured them of a sacred sanctuary. In 1614, Adrien Block sailed through the Long Island Sound and mapped out the region. The island appears on his hand-drawn map that now resides in the Netherlands National Archives. In 1639, settlers began to migrate to the area known then as Wepawaug. For some reason, Ansantawae sold the island and a large tract of mainland to forty English pioneers for the sum of six coats, ten blankets, a dozen hatchets and hoes each, a kettle, twenty-four knives and a dozen small glasses. Some accounts state the glasses were mirrors, but records just say "glasses." At that time mirrors, or looking glasses, were a tough commodity to come by, especially larger ones. The term "seven years' bad luck" is attributed to breaking a mirror because in castles and prominent homes, large mirrors could take up to seven years to obtain.

The colony then became known as Milford, the sixth-oldest settlement in Connecticut. The chief had an attractive and stunning daughter who raised the brows of both the Indians and settlers of the region. It turns out that the daughter was kidnapped just before the Paugussetts moved west to join the other tribes. The chief, convinced that the white man had executed the treacherous deed upon his daughter, cursed the island in such a way that "any shelter built there will crumble to the earth."

The first owner of the atoll, George Hubbard, tried his hand at farming on the isolated parcel, but the soil was tainted and nothing prospered. The island changed hands over the next few years until a man named Charles Deal bought it in 1657. The island was and is to this day named after him. He took a run at the curse and thought he would have a successful undertaking by growing tobacco on the island. His tobacco venture failed miserably, and he died in 1685, leaving the island for several more owners to wrestle the curse. By 1698, the land mass was owned by Elizabeth Couch, who, living in England at the time, had no plans to be an occupant of the inheritance she had assumed. In 1699, Captain William Kidd, one of the most notorious and successful pirates in history, made a stop in Milford on his way to Boston, where he was made to believe there was a pardon waiting for him. It is told that he buried a portion of his riches on Charles Island just before parading the streets of Milford with his men. After burying his booty, he was said to have placed a dreadful curse on the treasure so that anyone who dug for his ill-gained riches would suffer certain death. A common practice among the freebooters was to draw lots where one of the men was chosen to die. His body was then buried with the treasure, and his spirit would guard the cache from any rogues who might attempt to steal it. No one would ever discover where the treasure was located, for upon Kidd's arrival in Boston, he was arrested, tried, convicted of piracy and hanged at Execution Dock in London, England, on May 23, 1701. There were now two curses that weighed upon the soil of Charles Island.

This would not be the last hex to grace the isle that had already gained a reputation as tainted among the locals. In 1721, five sailors stole Mexican emperor Guatmozin's treasure and sailed it all the way to Connecticut. Upon finding his riches missing, he promptly proclaimed a curse upon the cache, stating that the perpetrators of the heist would suffer certain death and all who came in contact with it would suffer the same until it was returned to him. Four of the sailors died tragically when their boat overturned, but the fifth was spared—for a short time. The riches were well hidden in the basement of the Milford Inn, but apparently not well enough, for one night,

a drunk went down into the catacomb to seek more libations and stumbled upon the hidden hoard.

This forced the remaining sailor to extract the treasure and move it to Charles Island, where it was never seen again, as that sailor, too, died without ever revealing its whereabouts. This would not deter the first permanent resident of the island, John Harris, from building a mansion there in 1835. He purchased the land for $800 and dumped another $14,000 into making it his private paradise. As the curse would have it, Harris became very ill and was forced to sell his dreamland in 1841.

Around the time of Mr. Harris's tenure on the island, 1838 to be exact, two men stealthily stole to the south side of the island, where Kidd's treasure had reportedly been buried, and began their quest for fortunes unknown. Their relentless digging soon paid off when one of the men's spades struck the iron and wooden chest. It appeared that they were going to be quite wealthy until a screech beyond explanation pierced their ears from above. They both looked toward the stars and beheld the most hideous creature plunging from the heavens toward them. The headless skeletal demon dove into the hole, which immediately turned into smoke and blue flame. The two pillagers did not stick around for the smoke to clear. They were already halfway off the island by then. When they returned to the island the next day, they found that the hole had been filled in and the topsoil looked as if it had never been scathed with a shovel. As for the treasure, that too had vanished, never to be seen again.

By the time Elizur Prichard purchased the parcel in 1852, it had already gone through many more owners. No one seemed to have what it took to endure the curses of the island, except maybe Prichard. He opened the Charles Island Hotel in June 1853, and based upon the immediate success of his resort, it appeared that the curse was finally beaten. His daughter, Elizabeth, died a year later, and it was somehow blamed on the many curses of the island. In 1859, the barn on the property inexplicably went up in flames. Prichard ran in and pulled his beloved prized horse out safely, but for some unknown reason, the horse became bewitched and ran back into the engulfing flames. Prichard was also injured in the fire and never regained full health. On Thanksgiving Day 1860, Prichard collapsed while walking across the sandbar to the mainland. Two men successfully pulled him from the rising tide, but he passed away shortly after. The failing hotel closed after falling into bankruptcy in 1868.

Sarah Prichard leased the island to the Miles Company, which built a fish oil and fertilizer factory on the atoll. This lasted for about a decade before

the company financially sank. Sarah then made a deal with the American Yacht Club to lease the old hotel. Before the deal could be sealed in wax, the hotel caught fire and burned on August 1, 1886. Deep in debt, Sarah had no choice but to let the island fall into foreclosure.

Perhaps the most unlikely inhabitants of the island were the most pious of all who graced the sands of the cursed ground. In 1927, Father Edmund Baxter of St. Mary's Roman Catholic Church became the catalyst in building a retreat for the church priests and laymen alike called St. Aquinas Retreat. The retreat opened, but not before tragedy would strike once more. On March 30, 1929, six volunteer workmen attempted to row back to shore when their boat somehow capsized and all six perished. A stone shrine of St. Christopher was erected in memory of the six volunteers. Along with the shrine sat other statues, twenty-five buildings that included a chapel and cabins, a dining hall and paths where one could walk in natural solitude and harmony.

For unknown reasons, the Dominicans abandoned the retreat in 1936. The holy buildings stood, mocking the words of Ansantawae, until the Hurricane of 1938 hit the region, leveling and washing away almost all traces of the retreat. All that remained were stone foundations. True to Ansantawae's curse, every building put on the island crumbled.

Now, only the spirits of the island call it home. The causeway becomes a bridge to the unknown when the water ebbs, beckoning the less wary to a small world where the other side resides. Numerous visitors have witnessed these eerie, ethereal beings wandering among the trees, making no sound and "floating" along the dangerous edges of the shore without touching the ground. One fisherman who is a regular to the island once witnessed a man walking along the shore. He thought it very peculiar that the man glided over the rocks instead of swaggering among them in an attempt to manipulate the rough terrain. Although he could not make out the figure's distinct features, he knew beyond the shadow of a doubt that he was witnessing something supernatural. The curses have left a heavy mark upon the island. Its tainted heart beats with the pulse of the spirits of those who scoffed at the rants they soon became victim of.

If you decide to take a trip out to Charles Island, beware of the rising tide, but mostly pay heed to the curses that linger long after everyone who tried to break them has moved on. Well, maybe not everyone has moved on.

NEW LONDON'S LEDGE LIGHT

While peering into New London Harbor, a rather strange sight looms over the briny tide. At first, the surveyor of this spectacle might deduce that one of the stately mansions has somehow taken on sea legs and is drifting into the great blue. It seems rather anomalous that such a building would be sitting in the middle of the harbor, but yes, it is there. It is actually a lighthouse. The New London Ledge Lighthouse resembles a majestic Second Empire home, and there is a good reason for its architecture to be so splendid. Why it is haunted, however, is a matter of conjecture. There are stories, but none with exact confirmation. Be it so, activity of the ghostly report runs rampant among the walls of this one-of-a-kind beacon. Read on and perhaps you might help solve a bit of a conundrum as to who actually might haunt one of the most unique of Connecticut's haunted habitats.

The Ledge Light was one of the last lighthouses built in New England. This red brick edifice topped with a mansard roof sits near the entrance of New London Harbor on the extreme eastern end of the Long Island Sound. Its distinct French Second Empire style came about at the request of the wealthy homeowners along the shore who wanted the structure to keep in harmony with the elegant appearances of their coastal estates. Unfortunately, many of these fashionable homes were destroyed in the hurricane that swept through New England on September 21, 1938.

The lighthouse was established and built in 1909 to replace the inefficient New London Harbor Light. As New London became more of an industrial Mecca, it became necessary to direct vessels through the perilous ledges of

New London's haunted Ledge Lighthouse. *Courtesy of Jeremy D'Entremont.*

the harbor. The light is built upon a concrete and riprap platform. A riprap deposit, eighty-two square feet by ten feet deep, protects this foundation. A fifty-square-foot pier rising eighteen feet above low water was constructed with a cellar and two cisterns to collect water for the fifty-eight-foot-high lighthouse. It was originally called the Southwest Ledge Light, but the name was changed because there was a light in New Haven that already claimed that moniker.

The fourth-order Fresnel lens held an incandescent oil vapor lamp that could be seen up to eighteen miles away and was rotated by a clock mechanism that required winding every four hours. The original lens is now in the custody of the Custom House Museum of Maritime History in New London. Each lighthouse has its own characteristic signal so mariners can easily determine their position along the coast while en route to their destination. The present optic at the Ledge Light, a solar-powered lens, has three white flashes followed by a red flash every thirty seconds. The foghorn gives off two blasts every twenty seconds. During the Hurricane of 1938, Howard B. Beebe was on duty as keeper. The waves came through the second-floor windows of the three-story building, forcing him and his assistant to take refuge in the cast-iron light tower that sits on the mansard

roof. After the hurricane, Coast Guard crews were stationed at the light to keep it lit until it was automated on May 1, 1987. The day the light went automated was obviously a monumental event in more ways than one in regard to one of the guardsmen, for he wrote in the log, "Rock of slow torture. Ernie's domain. Hell on earth—may New London Ledge's light shine on forever because I'm through. I will watch it from afar while drinking a brew."

As far as the ghosts of the lighthouse, there is a popular belief that the haunting is caused by a man named John "Ernie" Randolph. Randolph is said to have lived at the light with his wife. If this were true, then he would have been an assistant or perhaps even a keeper between the years of 1938 and 1981. There is also a discrepancy as to who the main keepers of the light were between 1915 and 1926. Jeremy D'Entremont, president of the American Lighthouse Foundation and author of several books on lighthouses, performed extensive research on the history of the light and found that the names from that era were not recorded in any single payroll archive or record book. He also confirmed my suspicion that if a keeper had died at the light, there would have been some newspaper record or other documentation. He did not, however, rule out that from 1915 to 1926 a man named Ernie or Randolph may have been a keeper at the light. New England Ghost Project set forth another theory that the ghost could be that of a construction worker who fell from the roof of the light during the original construction of the building. This opens up a probability that Ernie might actually have been an unrecorded keeper, a worker at the light or, as Mr. D'Entremont also explained, a name given by the Coast Guard keepers to explain the strange occurrences at the ledge. Either way, the discrepancy in records and other historical data lends more credence to the ghostly legend.

As the legend goes, Randolph's wife could not take the seclusion of the lighthouse and became very depressed about living in the middle of the bay with very little contact with the outside world. She implored him to take another job on the mainland, but the keeper was steadfast in his duty. One day, she vanished from the light. He later found out that she had sailed off into the sunset with the captain of a Block Island ferry. Poor Ernie was so distraught that he climbed to the top of the light, slit his own throat and dove into the waters below. His body was never found, and from that moment on, Ernie was said to be the ghost that haunts the Ledge Light. When the Coast Guard became keepers of the light in 1939, cadets constantly witnessed doors opening and closing on their own and would have the bedcovers tugged on or just plain wrenched right off the bed as they unsuccessfully

tried to sleep. Televisions would mysteriously come to life with no one there to switch the units on. This was, in many cases, before the days of remote controls, so one would have to walk over to the set and turn the unit on by hand. The foghorn was also prone to ethereal antics. Even on the clearest of days, the horn would begin to wail. When inspected, it was always found to be in perfect working order. Some of the keepers would prepare to swab the decks of the light but, upon emerging onto the deck from the house, would stand there flabbergasted, as the decks were somehow inexplicably already washed down. Boats docked and tied securely would suddenly unknot and start drifting out to sea.

The 2009 multi-award-winning WGBY documentary, *Things That Go Bump in the Night: Tales of Haunted New England*, tells of an account by Guardsman Bill Rhodes Jr. Young Mr. Rhodes was stationed at the light from August 1979 to January 1980. Producer Anthony Dunne and videographer Mark Langevin interviewed Mr. Rhodes about his experience at the lighthouse for the documentary. With permission from all parties, I am able to present, in Mr. Rhodes's own words, an excerpt from that interview. Here is what he had to say:

I was stationed in New London's Ledge Lighthouse from August of 1979 until January of 1980. I start to hear stories from these guys that have been there, about Ernie, you know, this guy that was a lighthouse keeper who supposedly, his wife was fooling around or something. There was some kind of murder or something happened out there, and he is supposedly haunting the place. I am eighteen years old and I am like, you know, "Yeah, right, this is a bunch of crap." I did not believe it.

But I remember one night I was on the watch, working from 11:00 to 7:00. I had been hearing things creaking and groaning up there. Now, I had been up there earlier and everything was closed, and the door had a latch on it that you really had to throw hard. It was made to withstand hurricane force winds and weather, so it was heavy; it was not going to open by itself.

And that door was open. Now, how that happened, I don't know.

I cranked up the light for about thirty seconds just to make sure it was going. I closed the door, went downstairs, and I never went up there again at night. You know, when you are eighteen, you're not scared of anything. But when I was up there by myself at night, I did not like it. I truly did not like it after that; it made me nervous.

So that one assignment to the station changed me. It did change me a little bit; about the way I think about things.

Karen Mossey, noted EVP expert for ECTO, a professional paranormal group of the highest caliber out of New Hampshire, once caught another voice on her recorder that may not be that of Ernie. As Karen asked questions in hopes of getting an answer from the other side, she happened to inquire if there was anything she could do for the spirits. When she played back the recorder, she heard a voice loud and clear say, "Help me, I'm cold." The investigators were later told an account of a vessel that crashed on the ledges near the lighthouse, and the father and daughter succumbed to the ravages of the sea before they could be saved.

A keeper heard his name called several times while descending the ladder from the light tower. Although this may not seem monumental on the surface, it was rather disconcerting to the man, as he was supposedly the sole occupant of the ledge at the time.

A woman and her children once stayed at the light and got a visit from what may have been the ghost of Ernie. She was suddenly awakened one evening by something at the foot of her bed. As she focused her vision, she distinctly saw a semi-transparent figure of a man in a rain hat and slicker. The gaunt apparition stood over six feet tall and sported a beard. She was not the only one who witnessed the resident ghost, as her children were with her when the maritime spirit decided to pay them a visit.

Many other paranormal groups have investigated the light with the conclusion that the place is truly haunted. Some also experience cold spots or a feeling that they are being watched. But remember, it is in the middle of a harbor where the night air can be damp and chilly. The eerie seclusion can also make one think that he is not alone on the minute ledge. This does not take away from the century of haunts that swathe the light in a cloak of mystery. Whether it is Ernie or a few others who have made the signal their eternal refuge, it can be assured that the Ledge Lighthouse is ceaselessly aglow with spirits.

Tours of the lighthouse are available through Project Oceanography Avery Point.

Bara-Hack

THE VILLAGE THAT ECHOES THE PAST

W hen Odell Shepard visited what he called the "village of voices" in 1927, the settlement of Bara-Hack had lain abandoned for fewer than forty years, yet the woods had reclaimed their majesty among the foundations and ruins with breathtaking alacrity. Just having referred to the area as the village of voices denotes that it had already established a reputation for supernatural happenings.

The saga of Bara-Hack, which was reported to be Welsh for "breaking of bread," usually starts with the Higginbotham-Randall clans, but they actually were not the first landowners of the area. Jonathan Randall, a Rhode Island native active in that state's politics at the time, purchased 220 acres from Alexander Sessions on November 13, 1776. Born on March 20, 1706, Randall died in Pomfret in 1791 at the age of eighty-six. He is buried in Providence, Rhode Island, due to the fact that he was a judge in the Ocean State Supreme Court from 1749 to 1761. Obadiah Higginbotham purchased land from John Trowbridge, son of Daniel Trowbridge, in 1778. Daniel Trowbridge had purchased the land from Abel Lyon in 1731. Daniel had eleven children and married twice. When you think about it, the voices of Bara-Hack could have been speaking through the trees long before the Higginbothams or the Randalls settled there.

The 1774 Rhode Island State Census lists Obadiah as married with one white male under sixteen years of age in his household. Rhobadiah, daughter of Obadiah, was born in Rhode Island as well. Obadiah is later mentioned in the 1800 census along with his wife, Dorcas, and five children.

In the records researched, Obadiah and the name Higginbotham are spelled in various different ways, such as Obediah and Higinbotham.

Obadiah removed from Cranston with his newly formed family to the woods of Pomfret sometime around 1780. Obadiah then purchased land abutting the Randall property, and what we now know as Bara-Hack came to be. Eight children were born to Obadiah and his wife. Records indicate that Obadiah was a deserter of the British army. Desertion was common back then, as the British soldiers, facing aggravation from the townsfolk, would often let down their weapons to befriend the locals and even date the women. The locals would give them food, liquor, cigars and the like.

Obadiah started a small factory along the banks of the Nightingale Brook called Higginbotham Linen Wheels, which produced spinning wheels. He died in 1803 at only fifty-three years old, leaving his wife to take care of the property and factory. She sold some of the land to pay debts. The factory ran until 1853. Dorcas died on July 1, 1849, at the age of one hundred. She was buried in the small cemetery that holds members of both the Randall and Higginbotham families. The small fieldstone marker sitting next to her grave is very likely that of Obadiah's, as they were not wealthy when he died and probably never got an opportunity to procure a proper stone for his grave site. The last interment to the graveyard was Patty Randall, who died on March 30, 1893, at eighty-four years, six months. The elder Mrs. Patty Randall died in 1809 while giving birth to daughter Patty.

In the book *The Lost Village of the Higginbothams*, author and owner of the land Doris B. Townshend states that she could not find any Welsh translation for the term Bara-Hack. It does appear in Odell Shepard's book *The Harvest of a Quiet Eye*. He describes the village as such:

> *Here had been their houses, represented today by a few gaping cellar holes out of which tall trees were growing; but here is the village of voices. For the place is peopled still although there is no habitation…yet there is always a hum and stir of human life. They hear the laughter of children at play. They hear the voices of mothers who have long been dust calling their children into the homes that are mere holes in the earth. They hear the snatches of song…and the rumble of wagon wheels along the old road. It is as though sounds were able in this place to get round that incomprehensible corner to pierce that mysterious soundproof wall that we call time.*

In the 1950 book *Folklore and Firesides in Pomfret, Hampton and Vicinity*, author Susan Griggs speaks about the Higginbotham family and subsequent mill as

The Higginbotham cellar hole at Bara-Hack, also known as the village of voices.

she refers to the area as the "Lost Village in the Hills," yet she never mentions the term "Bara-Hack." She does refer to the burying ground as being called "God's Acre of the Hills" by the descendants of the Higginbotham family.

Legends of the village of voices reach as far back as the eighteenth century, when the two families thrived there. It was recorded that the Randall family servants spied strange gremlin-like creatures the size of small children reclining among the boughs of the great elm that stood on the north face of the graveyard. The elm has since succumbed to age and the ravages of nature, but the trunk still towers over the cemetery wall as an interminable monument to the preternatural.

In 1971, student and paranormal researcher Paul Eno investigated Bara-Hack with a small group of colleagues. They not only heard the voices echoing through the trees but also heard the lowing of cattle about them as if livestock once again tenanted the overgrown fields. At one point, they witnessed a bearded face hovering over the cemetery wall for several minutes before vanishing. At dusk, orbs and blue streaks of light began to flicker about the graveyard. Arlene and I have since become friends with Paul and his son Ben. We seem to share a common bond with our experiences at Bara-Hack.

Our many visits to the lost village with the permission of Mrs. Townshend proved that Bara-Hack still holds the spirits of those who once wandered its fields in life. During one visit, while studying the names and dates within the cemetery, the sound of horse's hooves and wagon wheels crunching the gravel trail could suddenly be heard in the distance. At first I thought it was a wagon from the 4-H Club passing through. As the sound grew near, we ventured over to the old road. The sound grew louder until it was upon us, moved past and faded down the trail. The whole scene transacted in front of us, yet there was no visible entity whatsoever to create the ghostly din. At that point we knew we had just experienced the permanent residents of Bara-Hack.

On another trip through the lost village, Arlene decided to take photographs, as the October morning was sunny and mild. We entered the village on the usual path. As we neared the first foundation, we both felt like the woods were actually alive. All around us it felt as if there were invisible eyes piercing the woods, glaring at our every move. By the time we got to the cemetery, Arlene and I sensed a great anxiety and need to leave the area. It was the first time in countless investigations that we had become completely enveloped by such an eerie sensation.

We have heard the voices of the children laughing and the clamor of conversation permeating the air on a few occasions. The latest was several months prior to this writing. On three previous visits before, the ghostly village had seemed peaceful and inviting. In fact, it made for a storybook setting as the sun beamed through the trees and the birds chirped merrily from above. It was hard to believe that this was a place where time has a tendency to warp, causing the past to join the present. The voices seemed to start softly, slowly growing in volume until it was unmistakable that there were children scurrying amid the woods, within sight but not visible.

The most recent experience was somewhat similar. Arlene and I visited the settlement with fellow investigators Rich and Ally Allarie and Ally's mother, Debbie. We ventured out to the burial yard and held vigil there for several minutes. Then it happened. The voices slowly began to filter in with the breeze, and before long it was a faint symphony of laughter, conversation and shouts that seemed to enter our ears from all around us. The sounds were not loud but they were there, and we were able to catch them, though faintly, on the recorder.

In my research, as stated before, there were other previous owners of the land. Most people seem to think that the haunts began after the area became abandoned by human habitation, but the Randall servants saw creatures

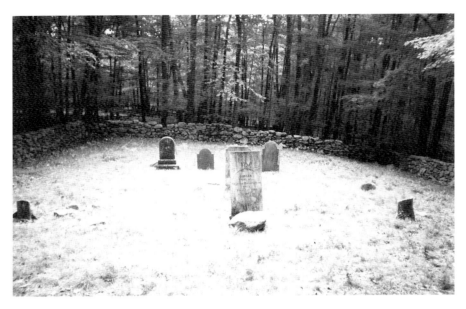

The cemetery at Bara-Hack where members of the Higginbotham and Randall families are buried.

What appears to be a possible orb moving over the cemetery at Bara-Hack. Note the sun is behind the camera.

in the trees. What other occurrences transpired that were not formally penned for later perusal, and how many previous families also experienced the paranormal phenomena of Bara-Hack? Perhaps it is members of the Trowbridge family that still speak, or a mixture of all the families that resided within the area, as Odell Shepard stated, breaking through the barrier of time. No one is sure of the identities behind the voices, as there were many children from the Trowbridge and Higginbotham families that resided within the realm of the haunted hamlet.

The remains of the bridge and dam are just below the Higginbotham foundation. The Randall home was demolished, and a new one built by George Randall took its place. Rhobadiah Higginbotham eventually owned the parcel of the land that abutted the Randalls' property, including the cemetery. There are several remains of buildings and lots of stone fences to remind those who venture through the settlement that human life once thrived there. Then there are the voices.

CAPTAIN GRANT'S GHOSTS

Captain Grant's Inn was originally built in Preston in 1754. Records contend that the Whipple family, ancestors of Mrs. Mercy Avery-Grant, built it. Grant died at sea at the age of thirty-two, while Mercy lived into her eighties, and the home continued to house three generations of the Grant family. During the Revolutionary War, soldiers used the home as a garrison, and during the Civil War, the home protected runaway slaves. Carol and Ted Matsumoto purchased the house while it was in a very sad state of decay. It had been used for apartments and fallen into neglect. A major restoration took place from 1994 through 1996, when they added such features as wide-board hardwood floors, 253-year-old hand-hewn beams and an authentically rebuilt seven-foot-wide staircase. The original banister and balusters had been kept in oak barrels for over 100 years until the restoration commenced. Upon ascending the wide staircase, visitors are greeted with a mural of the Poquetanuck Cove as it looked in 1825. A three-story deck, built on the home's east side, allows guests to experience the rising sun while enjoying their morning cup of coffee. A full country breakfast is served every morning in front of a crackling fire. Today, the inn stands restored to its original grandeur and prominence in this National Historic Village. A few spirits have also been awakened by the restoration.

The seven guest rooms are furnished in period antiques and reproductions. The atmosphere is very cordial, as are the innkeepers. Carol is outgoing and always helpful. Arlene and I stopped in on a winter's day for a chat about ghosts. It seems there is a lot of friendly spirit in the inn, both living and

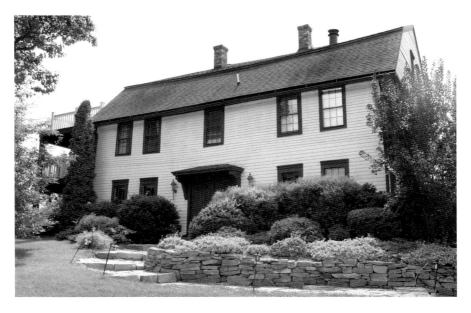

Captain Grant's haunted bed-and-breakfast in Preston.

otherwise. This positive energy always draws more of the same. So it is no wonder the mostly unseen residents of the inn are harmless.

According to Carol, a police officer once stayed at the inn. In the morning, he commented on how loud Carol and Ted had been while rummaging through the attic in the small hours of the night. Carol then told him that no one had been in the attic due to the fact that there are large planks up there and no one can maneuver around the beams at all. He was sure he had heard heavy footsteps moving from one end to the other. Carol then took him to the attic, where the surprised guest stared at the large piles of wood that lay strewn about the rafters. Neither of them could even advance enough to get into, never mind stomp around, the attic. "He has been here five times since," Carol said amusedly. Many more of the guests have come down in the morning inquiring about the loud tenants above them, and Carol just explains that there are no rooms in the unfinished attic. That is when they realize they had an encounter with a ghost.

One of the most compelling accounts was of the apparition of a little girl. One of the staff members, Amy, was tidying up the rooms. For three days in a row, she had encountered the mini blinds bent in such a way as if a child were trying to peer through them. For the third time, she walked over

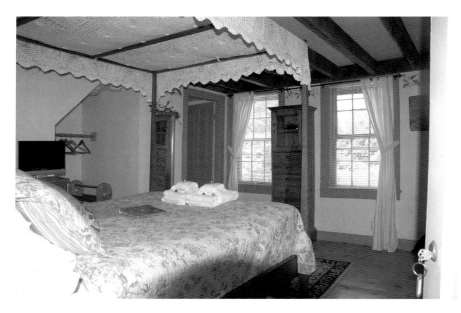

Window in the Adelaide Room at Captain Grant's, where the ghost of a little girl appeared.

to the window and began straightening the blinds. That was when a little girl suddenly materialized right next to her and walked right through her arms. Amy (who was until then a nonbeliever in the stories at the inn) was so shaken by the incident that she hastily left the house. Her mother, Joan, was also employed at the inn. Joan is well acquainted with the spirit shenanigans at Captain Grant's.

More updates were related to Arlene and me when we returned to the inn in August 2008. This time we were accompanied by fellow Paranormal United Research Society (PURS) member Kevin Fay and Greenville Paranormal researcher Andrew Lake. Carol related to us that more incidents had taken place since our last visit and gave us some time to perform an investigation. We were also able to venture out into the cemetery located on the property that, in the winter months, had been inaccessible due to the deep snow.

"Of the seven rooms, the Adelaide Room seems to be the most active," Carol said. Shortly after our first visit, the spirit of a woman had appeared to one of the guests in the Adelaide Room. According to the stunned guest, she was wearing a long, old-fashioned dress as she become visible right in front of her and then, within a few moments, vanished. "That does not happen

all too often," Carol told us. "But we do continue to have orbs around here. Lots of them."

Several guests have heard walking up and down the hallway. It sounds like more than one person shuffling around. One guess is that it may be one or both of the two sisters who once occupied the home. They were not on speaking terms with each other, so they partitioned off the large stairway, had the double doors installed in front and lived on separate sides of the house. In time, this dividing wall was taken down and the house made whole again. This act may have stirred up the sisters' energies, as now they have to endure each other's company within the walls of their former abode. One night there was only one room rented, and the quiet solitude was surely going to be a blessing for the guests. That is, until they heard the phantom footsteps passing through the hall. Carol locks the doors when there is only one guest room rented, and the driveway and house are outfitted with alarms so they can see or hear if others might be arriving. "No one else was there but us. When we have one couple here like on that particular evening, we will get up and investigate, even though we know we are supposedly alone in the house," Carol said.

There is a twelve-inch-high sand doll used as a doorstopper in the Adelaide Room that seems to move on its own. The staff and guests never know where the doll is going to end up. The guests who stayed in the Adelaide Room the night before our visit told Carol the next morning that the little doll had ended up in the bathroom when they woke up, yet it started out behind the door to the room when they went to bed. Carol chuckled and told them that she has ended up in the Collette Room, the Amy Room—everywhere in the house. The people staying in the room had come in hopes of experiencing the ghosts of the inn, and they were not disappointed. Having known of the story involving the little girl ghost and the staff, they went out and got a small doll to put in the bathroom for the little ghost child of the manor to play with.

Our investigation produced nothing out of the ordinary. We scoured the inn, logging in the equipment's readings and shooting some photos of the places in question. The readings on the EMF meters and thermometers were normal for the time of year. We had really hoped to capture some EVPs and relish in hearing what the ghosts of the inn had to say. Later, when we listened to our vigils recorded in the rooms, we would hear nothing to confirm evidence of the paranormal. We then ventured out to the cemetery behind the house. It was a bit overgrown but maneuverable to a point. Among the brush and bramble sit the stones of Whipple family members. We continued

The small, overgrown burying yard behind Captain Grant's is where Paranormal United Research Society member Kevin Fay recorded an EVP.

with our investigation of the site in the graveyard. Arlene and Andrew took photos, while Kevin and I attempted to obtain some EVPs from opposite ends of the burying ground. I did not capture anything, but Kevin caught a strange noise on his recorder that sounded like a voice sighing or letting out a note of surprise at his presence. On the recording, Kevin's voice is in the forefront and ours are farther away, as we were all on the other side of the burying yard. It is obvious by the distance in our voices we were not near him, but someone was and they spoke.

With all the ghostly happenings at the inn, one visit just is not going to suffice. Of course, if you stay the night, you might get a visit yourself. Don't worry; the spirits there are not harmful in any way, just curious as to who is a guest in their home.

THE JOHN YORK HOUSE

Connecticut is rich with historic sites. Those who hold a love for their heritage and history have often preserved them for others to behold and relish. It is no wonder that many of these locations also harbor a spirit or two from the past. These spectral inhabitants have a tendency to remain in the residence they so loved in life. Sometimes they even linger about to assist the new owners in the never-ending battle of keeping up these old homes. Others may be bound by an event that transpired long ago, leaving them trapped to finish some business that only they may find the answer to. The latter was the case of the John York House in North Stonington.

Gene Poulliot purchased the home in 2008 from the Grotes, who were the last to run it as a bed-and-breakfast. Arlene and I were doing a book signing at Mystic Seaport when Gene approached us with the possibility of a paranormal investigation in his newly acquired home. He had heard the legends in regard to the house and thought it might be a good idea to see if they held any validity. As for us, we were elated to check out a landmark of Connecticut history. I had read many accounts of this antiquated ordinary and always wanted to spend some time there hoping to communicate with the alleged spirits that dwelled within.

Armed with equipment, Andrew Lake of Greenville Paranormal, Matthew Moniz of Spooky Southcoast, my brother Donald and his wife, Sheila, accompanied Arlene and me to the house. We set up in our usual speedy manner and were holding vigils in no time. Before I divulge our experiences, here is a brief history of the home and its haunt.

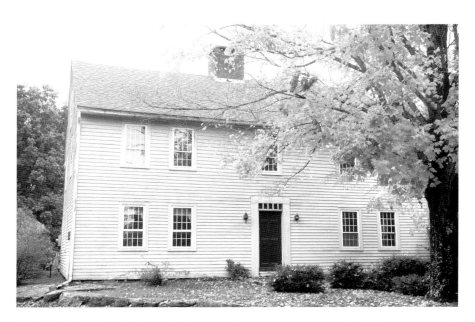

The John York House in North Stonington, where some very powerful EVPs were recorded by Paranormal United Research Society.

John York was a successful businessman and farmer when he built his home in 1741. He later turned it into a tavern and inn around the time of the American Revolution. It was during this time that two Continental soldiers, who were best friends, sat in the Great West Room (presently the library) one evening for a relaxing chat. The conversation turned toward a beautiful woman whom both men had a keen affection toward. They soon found themselves arguing, and a bloody fight ensued, during which one of the soldiers, in a fit of rage, plunged a knife into the other, killing him on the spot. The murderer ran from the scene and was never seen again. Accounts state that he either reassigned himself to a ship or became a stowaway aboard one in order to flee justice. Either way, he was reported to have fallen overboard and drowned.

John York tried to soak up the bloodstains on the floor with sand, but to no avail. He ultimately had to pry up the tainted floor planks and turn them over. It was shortly after that when the haunting of the York House began. At first they were temperate occurrences, such as objects disappearing and reappearing somewhere else in the house, or shadows out of the corner of one's eye. This went on for about two hundred years before the haunts escalated to a new echelon.

The fireplace in the library of the John York House, where two Continental soldiers fought to the death.

The Wilms family purchased the home in 1963. Mrs. Wilms was so intrigued by the ethereal occurrences that she began to hold séances in hopes of contacting the spirits of the house. She must have succeeded, because the haunting grew with such intensity that furniture began to topple over and items began to fly off the walls. Family members also frequently smelled the odor of pipe tobacco, although no one in the family smoked. Clothes and shoes would be found in piles on the floor, and footsteps were heard throughout the house when those areas were void of the living. Door locks began to unlatch by themselves, and even a vacuum cleaner decided to start on its own volition. The most shocking event was when one of the Wilms boys awoke in the middle of the night with what resembled handprints clearly visible around his neck. They were also interrupted by what sounded like cannon fire. This is when the family called famous paranormal investigators Ed and Lorraine Warren to the house.

The Warrens claimed that the spirit haunting the house was that of a Revolutionary soldier who was trapped there by guilt and sadness. They performed a cleansing ritual that supposedly drastically reduced the intensity of the haunting within the residence. It was not much recourse

for the Wilmses, who had experienced more than they cared for already. In 1987, the family moved away from the York House.

There was also an account of a guest who fell down the stairs in a drunken stupor and broke his neck. The back stairs leading from the dining room are very small and steep. One could easily slip going up or down them. It is reported that his ghost, a bit more irritated than the other presences in the place, still roams the area of his demise.

The next owners, Leea and David Grote, stated that they had not experienced anything out of the ordinary since they acquired the York House in 1997. They turned it into a fine bed-and-breakfast with four wonderfully furnished rooms. Each room had a fireplace and private bath, along with lovely heirloom antiques. Guests could expect to wake up to the smell of fresh bread and an exquisite breakfast that would have roused the most profound sleeper from his chamber. On the other hand, many of the Grotes' guests claimed to have had paranormal encounters while visiting the inn.

Our first stop was the basement, where we attempted to find the bloodstained boards with black lights, but the ceiling had long been covered and insulated. The exposed support columns did not have any evidence of a colonial fight either, and we were soon back in the library hoping to talk with one of the spirits. The first few hours seemed rather quiet, but as the day waned and darkness set in, we began to feel the energy coming out to join us in the twilight hours. It could be surmised that when it was a hostel, those who came down to dine and have a drink would do it during that time of the day. Having little or no lighting would make this a plausible possibility. It was not until later, when we held vigils in the bedrooms, that we would catch some eerie evidence through EVPs proving that the John York House is still tenanted by someone from the past.

During our vigils, we asked many friendly questions. It is our protocol to ask only nice questions such as you would if you were having a welcoming conversation with anyone. Would you want to answer someone demanding you to speak? One question Arlene asked was, "How many people live here?" When I played my recorder back, there was one voice that clearly stated, "Shut the door." Maybe it was John York trying to conserve on heat, or maybe, being an hour when the sun had gone down, they were used to bedding down at that moment and we were bothering them. It could have also been a random residual voice we were lucky enough to catch at that moment.

Another startling EVP was obtained in the room where the Wilms boy had encountered the less-than-jovial entity. This room is also at the top of

the staircase where the man supposedly fell to his death. Another question was, "Did you build this house?" and a voice clearly answered, "Go away." It was not only caught on the digital recorder but also on the handheld camcorder. Maybe we were keeping the spirits up later than they wanted or, as the house was vacant for a spell, they liked it that way. Either way, Gene's question was answered.

It was never anything malevolent, just intriguing. But the history and, in some cases, haunts are one of the most indispensable charms of old bed-and-breakfast inns. We never felt any negative energy, and the Poulliots were very friendly and personable. If they decide to open it as a bed-and-breakfast again, it can be assured that they will have a lot of guests. The spirits can be considered the best critics on how welcoming a place is. For the ghosts to have wanted to stay that long, it must be worth it.

Nipmuc Fishing Fires

The many Indian names given to the various towns and pieces of real estate throughout the Nutmeg State attest to the profound impact the many different tribes had upon the region. Names like Oneco and Uncasville are but a few town monikers that pay homage to the great warriors and sachems who once lived in harmony with or waged war against the settlers from across the ocean. Even the name Connecticut is derived from the Indian word *Quonectacut*, which means, depending upon who you query, "the long river" or "river of pines" in regard to the watercourse that divides the state into two parts.

Many tribes found prosperous hunting and fishing grounds in Connecticut. Among these tribes were the Nipmuc, who settled in Thompson on the northeast border abutting Rhode Island and Massachusetts. They toiled the fields and constructed great earthen strongholds on Fort Hill for protection from possible invaders of their settlement. Their chief, Quinatisset, erected his lodge on the site that the Congregational church now holds rights to. These people also worshipped in awe the great spirits of *Chargoggaggoggmanchauggagogg* pond, also then called *Chaubunagungamaugg*, meaning "fishing place at the boundary." When Samuel Slater began operation of his mills on the lake, it would later combine the name with "Englishmen at Manchaug," thus creating the present name, *Chargoggaggoggmanchauggagoggchaubunagungamaugg*, meaning "Englishmen at Manchaug at the fishing place at the boundary."

The word Nipmuc and its derivatives basically translate into "freshwater people," as the tribe was endowed with the talent and fortunately the taste for

acquiring and preparing freshwater fish. This fondness for fish outweighed their appetite for meat, and they found themselves trading corn and game with the Narragansett tribe for their catch of the day. The Narragansetts, aware of the Nipmucs' flair for shellfish and bluefish, sent forth an invitation for the two to join in a feast. Both parties reveled in food and fun with fresh- and saltwater seafood abundantly overflowing from the tables.

It was not long before the Nipmucs returned the invitation to the Narragansett tribe, and another great feast was scheduled. The Nipmuc Indians prepared freshwater fish, corn, squash, beans and eels, while the guests brought some oceanic delights and one of their own delectable creations: a special bread made from crushed corn and wild strawberries. The bread was presented as a gift, and the feast commenced.

During the feast, the Narragansett sachem noticed that the bread was never put on the table. Over a period of time, he grew irate and felt insulted by their lack of interest in his tribe's gift. This led to harsh words, and within moments, a battle between the two tribes broke out. The Narragansetts were easily slaughtered as they had come in peace, without weapons. Some escaped back to their village and declared revenge, but most died in the fight and were buried near the waters of the Nipmucs.

It became a great time of celebration for the Nipmucs, and they decided to hold a grand powwow of their own on the spot where Lake Alexander now sits in Danielson. There they set up camp and began a three-day-long gala where men, women and children played games, ate and drank without care or reservation. Soon it became a party of reckless abandon that lingered into a fourth day. The Great Spirit, already angered by the bloody squabble and treachery that had prevailed shortly before, had witnessed enough and decided to end their unruly merriment and mirth. While the revelers were deep in their celebrating, the earth beneath them began to give way, causing the deep underground streams and rivers to rise and flow until they flooded the whole area where the tribe had been whooping it up. Every man, woman and child at the powwow was said to have drowned from the vengeful hand of the Great Spirit. All but one, that is. The very apex of the hill where an innocent and devout old woman had been resting was spared the wrath of the Great Spirit. This island is now called Loon's Island. Whether or not the story is told exactly as I have heard it is a matter of little consequence, for there exists evidence below the surface of the lake that lends credence to the legend. When the sun's rays beam onto the surface, illuminating below the ripples, there can be seen the remnants of the tall trees that once stood sovereign on the now sunken hillsides.

To this day, every seven years, strange columns of blue light rise from the fishing areas where the tribe once lived in peace and harmony with the land. These lights are thought to be the spirits of the Narragansetts buried nearby, as they rise from the ponds and streams, reminding all of that fateful day when they were mercilessly eradicated. Legend contends that the lights may also be the essence of those who perished in the god's wrath upon the tribe. It is their spirits still watching over their once abundant fishing ground.

DANIEL BENTON HOMESTEAD

Love is said to be eternal. Proof of that may be witnessed at the Daniel Benton Homestead in Tolland. Several ghosts have haunted the home for more than two hundred years. Two of them are said to be young lovers who were separated by war and disease in life and a carriage path in death. This next account is full of history, mystery and investigations that will leave you, the reader, wanting to fully absorb the centuries of life that still linger in this famous historic landmark.

In 1720, Daniel Benton built the colonial cape the same year Tolland became established as a town. The home was a bit more extravagant than most would have built at that time in the colonies. Many homes had but one or two rooms where a large central fireplace heated the area as well as provided ample space for cooking and baking. As usual, the bed would be placed in a corner of the great room and linens would enclose it in order to keep the cold bite of winter or the itchy bite of summer pests at bay.

As time marched on, these houses were expanded to keep up with the eras and growth of families. Mr. Benton had a son who served in the French and Indian War. He also had three grandsons who answered the call to arms during the Revolutionary War. One of his grandsons, young Elisha Benton, had fallen in love with Jemima Barrows, a woman almost eleven years his junior. Elisha was born on August 9, 1748, and Jemima was born on March 28, 1759. Historians say that the relationship was doomed from the beginning, not necessarily due to the age difference so much but because she was born of a different class than Elisha. Her father was a cabinetmaker

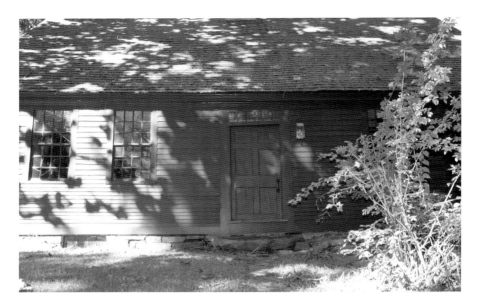

The Daniel Benton Homestead in Tolland.

and not as well-to-do as the Benton family. Still, Elisha promised his heart to her and swore he would return for her hand in marriage. With that, Daniel's three grandsons set off to fight for the independence of the colonies.

Unfortunately, all three were captured by the British and put onto prison ships anchored just off the shore of Brooklyn, New York. Elisha, captured during the Battle of Long Island, was left to endure the brutal conditions aboard one of these ships from August 27, 1776, until January 3, 1777. Sanitary conditions were unbearable, and the scanty rations of food were rotten and rodent infested. The three brothers came down with smallpox while imprisoned within the holds of these vessels.

Back in Tolland, Mr. Benton received word of the deaths of two grandchildren from smallpox while on the prison ships, but there was no word of his favorite, Elisha. Unfortunately, Daniel Benton died just shortly before the news of Elisha's freedom came to his door. Elisha was subsequently traded for another British prisoner and allowed to return home. Regrettably, his condition was grave from the smallpox he had contracted. The family, although elated by his return, had no choice but to quarantine the young man, as smallpox in those days was quite deadly. They made a wall between where he lay and the rest of the house in the hopes of containing the deadly virus.

Jemima had heard the news of her lover's return and swiftly made her way to the Benton home. There she saw Elisha on his deathbed suffering with fever and fading fast. She refused to leave his side, nursing him and feeding him, knowing full well that she could soon suffer the same fate. Her parents came to comfort the Bentons and were shocked when they saw Jemima by Elisha's bed. They also feared she would soon fall victim to the fatal disease and refused to go near her. The threat of contagion left them with no choice but to leave her at the side of her betrothed. That would be the last time she would ever see her parents again in life.

A few weeks later, on January 21, 1777, Elisha died. The family actually removed him through the window beside the bed so as not to spread any germs from the deadly affliction through the home. On February 28, 1777, just a little over a month after Elisha's passing, Jemima succumbed to the dreadful disease. Her fate was not so comforting, as she died alone with no one brave enough to care for her. Since they were not married, it was forbidden for them to be buried side by side. Elisha was buried next to the carriage road leading to the back of the home. Jemima was buried on the opposite side of the carriage trail that ran along the property, about forty feet

The area in the Daniel Benton home where Elisha Benton and Jemima Barrows were quarantined after contracting smallpox. Note the marks in the floor where the wall was constructed.

from Elisha. Even in death, they would not be joined. These two graves can be seen to this day in the front yard next to the stone fence. Inquiries as to why they were buried in that particular spot have resulted in shrugged shoulders and a reply of bewilderment in regard to the odd nature of the location. One would conclude that it would have been customary to bury them in the family burial ground, but instead the two lie in repose on either side of the little path. (In some cases, families buried those who died of contagious diseases outside of the family burial yards. They feared the diseased body could somehow infect them when paying their respects at the graveyard.)

The home remained in the Benton family for six generations until Florrie Bishop Bowering purchased the property in 1934. Bowering restored the home to its original colonial splendor while living there with a handyman and maid. In 1969, it was handed over to the Tolland Historical Society. There are still some Benton family members who may reside within the walls of the structure, along with what many believe are the spirits of Hessian soldiers who were held at the house after the Battle of Saratoga. Being close to the Boston Post Road, the home was a perfect location to hold the captured mercenaries. The food was good and there was plenty to go around, and the house had a large fireplace to keep warm. The soldiers were well cared for. It is no wonder many of them stayed in Tolland after their release. It is also no wonder a few of them stayed in the home after their release from their mortal chains.

Bowering's maid often witnessed the specter of a young woman in what appeared to be a bridal gown wandering through the house, weeping. Others through the years have seen this same specter. A woman and her friend, who was writing a college paper on the Benton haunts, saw the same ghostly image in the room next to them. When one of the women set out into the room to encounter the spirit, the entity vanished. Neighbors once stayed at the house while theirs was being renovated. One evening, they saw the fireplace in the living room begin to glow as if there were a crackling fire within the chamber. They also heard footsteps coming down the hall, followed by a loud thud. The supernatural phenomena lasted for several moments. Then all was quiet—except for the frightened guests hastily retreating out the door.

Some claim to have felt a pervading sadness while viewing the graves of Elisha and Jemima and have even felt the hair on their necks and arms stand up as if they were being watched by an ethereal being.

A man and woman staying at the house had an unusual encounter. The woman awoke in the night to find a strange-looking man in colonial garb

motioning toward her. The figure then cupped his hand over her mouth. She wrestled his hand away, and the wraith vanished. She then looked over at her husband, who was still asleep. Was it a dream, or was she really awake when the occurrence took place? Either way, it was quite an unsettling experience for her.

Neighbors have seen lights flickering and figures moving about the homestead long after everyone has left, locked the place up and activated the alarms. Many have also seen the shade of a colonial soldier standing at the front door. Some say it is the ghost of Elisha looking for his true love, while others seem to think it might be one of the Hessian soldiers who once stayed at the home.

Cold spots and voices are also common in the basement, as that was where the eighteen Hessian prisoners and two officers were held. The third floor is home to ghostly footsteps that can be heard at all times of the day and night. The haunting goes back to when the first generations of Bentons lived there, shortly after Elisha and Jemima died.

With so many stories being chronicled through the centuries, it is no wonder that John Zontock and the Northwest Connecticut Paranormal Society had to check out the abode for themselves. The group spent five nights in the home and recorded countless hours of video and audio, as well as hundreds of pictures. They heard a lot of strange noises but were able to explain some of the weird occurrences as natural and not paranormal. Some, on the other hand, could not be passed off as natural or normal. In the end, Zontock told me that they had caught a few EVPs that made them wonder and had photographed what appears to be a colonial soldier looking out of the window.

One of the EVPs was of a strange dialect. The word "wurdig" was translated from a northern German dialect as basically meaning "worthiness in the military." The other EVP they got, "Ryan," may have been "Rhine," possibly meaning the Rhineland, where the Hessian soldiers had come from. As for the figure in the window, the director of the Benton Homestead, Gail White, studied the picture and simply said that it was Elisha. The NWCPS is a very well-trained and organized group that investigates in a professional and thorough manner. Its members are highly recommended in their field. Their evidence is quite convincing that the Benton Homestead is still alive with the past.

Arlene and I visited the homestead on a Sunday in September. The director was not there, but the home was open for tours nonetheless. We immediately began snapping pictures and recording for voices. The rooms were of equal

The monument dedicated to Elisha Benton and Jemima Barrows sits near their gravestones at the Daniel Benton Homestead.

temperature, and the EMF meter never gave any sign of activity. The marks on the floor were still visible where the Benton family had erected a wall to quarantine Elisha from spreading the dreaded smallpox. The house seemed rather pleasant to be in, and we were very happy that we had taken the time to trek out to Tolland to tour the haunted historic site. Although we did not capture any paranormal evidence, we cannot dispute the centuries of those who have seen the ghosts and heard their noisy rambles at the homestead. Take a tour of the home. If you see someone dressed in period clothing, chances are that it is not a tour guide—at least not from this side.

THE YANKEE PEDLAR INN

Frank and Alice Conley had a dream. They wanted to own the most lavish hotel in all of Connecticut. Mr. Conley had worked at the Gelston House in East Haddam and the Allen House in Torrington while saving to someday own their own establishment. In 1890, they purchased a 100- by 214-foot lot at the corner of Main Street and Maiden Lane in Torrington for $8,000 and began to build the most ornate and appointed hotel in the region. With white and black marble floors, wainscoting, carpeted floors, fireplaces and appointments of meticulous design, their dream was realized on July 28, 1891, when the Conley Inn opened for business.

They ran a very successful venture until their deaths in 1910, when the business was inherited by their niece, Mary Tyron Reed, who had actually laid the first brick to the building. She sold it in 1912, and from there it changed hands quite often. In 1956, the hotel was renamed the Yankee Pedlar Inn. This moniker had already been given to the restaurant at the establishment, so it seemed fitting to combine the two under one name.

Today, the inn has sixty wonderfully decorated rooms, a tavern and a restaurant that immediately transport guests back to the age of splendor and Victorian charm. Each room has modern amenities and a private bath. The tavern and restaurant have cozy fireplaces, with the ballroom sporting a grand fireplace. It is truly a magnificent ambience to relish in, which is what Mr. and Mrs. Conley originally had intended. In fact, it seems that they are still making sure the inn lives up to the standards they set over a century ago.

There is an antique rocking chair in the lobby that belonged to Mrs. Conley. Many witnesses have seen the chair start rocking back and forth as if someone was sitting in it. Room 353 is where Mrs. Conley died. It is now used for storage, as many guests got uneasy feelings and were overcome by the smell of a strange floral perfume while in that room. For the more doubtful of the paranormal, the accounts are documented in a logbook. A guest in Room 295 felt someone climb into bed with him. He thought it was his wife, but when he rolled over he saw, to his astonishment, that she was still in the bathroom. One of the housekeepers has seen the ghost of Mrs. Conley wandering about the building. She was easily recognizable, as her portraits adorn the walls of the building.

Mr. Conley seems to show up every now and then as well. There is an old phone in the tavern that was original to the building. Many people have entered the room only to become startled by a gray-haired figure in a black suit resembling Mr. Conley speaking on the ancient device. The night clerk has heard knocking on the door to his office, but when he would open the door, the area was void of the living. Perhaps it is Mr. Conley checking up with the clerk on how the guests are doing.

Luke Edwards has not only been the night manager for several years at the inn, but he is also a paranormal investigator. One night, he and a friend were sitting in the lobby trying their luck at catching EVPs on tape. The idea is to ask a question and then wait ten to fifteen seconds before asking another. If the ghosts answer, you will not hear it until you play back the recording, as spirit communication is more often than not electrical in nature and not so much acoustical. Both of them said something during a recording session, but on playback, they heard a third voice, that of a woman, saying something they could not understand. He has also heard the stairs creak when no one is on them. "I know the difference between the building settling or the wood expanding and contracting from temperature changes. That happens as well, but there is a definite series of creaks when someone is on the stairs that is unmistakable," Luke said.

One night, he and a friend watched in amazement as a plate that rests on a shelf in a groove ten feet above the floor flew up out of the groove and sailed outward about four feet onto the middle of the floor, landing perfectly and gently on the thin carpet. Luke told me, "If it had just fallen, it would have landed on the chair below. The shelf is ten feet in the air. The plate would have shattered on impact."

The couple may not be the only haunts at the inn. A night clerk has also seen a black mist float through the lobby on occasion at about 1:00 a.m. The

housekeeper once witnessed a dark figure in the basement when she went down to get a vacuum cleaner.

Northwest Connecticut Paranormal Society held an investigation of the Yankee Pedlar Inn, but the spirits were quiet that night. They did get a few personal experiences but nothing to conclusively prove the ghosts were there. Maybe they felt everything was all right that night and decided to take a rest. Eternally watching over your hotel can probably be a bit tiring sometimes, even from a ghost's point of view.

THE GHOSTS OF
PACHAUG STATE FOREST

As the shadows grow long and darkness envelops the terrain around Pachaug State Forest, unearthly shrieks permeate the wooded domain. They are the shrieks of an Indian girl who was killed by British soldiers over three centuries ago. The once flourishing village that is now deserted thicket is host to several creepy entities, from colonial soldiers to the wraith of a little girl. There is even a black misty figure that stalks visitors to the foreboding wood.

The ghosts seem to fall neatly into the history of the forest. Pachaug is Indian for "bend in the river." The Narragansett, Mohegan and Pequot tribes inhabited the area. Toward the end of the seventeenth century, the colonists began to settle there and convinced the Mohegan tribe to be rid of the others. After they had gained the help of the Mohegans in successfully ridding the region of the other two tribes, the colonists then turned on the Mohegan tribe, forcing them out as well.

Around 1700, a six-square-mile expanse of land was given to veterans of the Indian wars. They named the new settlement Volunteer Town due to the fact that they had been volunteer soldiers during the conflict. In 1721, they shortened the moniker to Voluntown. The community was quick to spring up along the fast-flowing Pachaug River, which runs through the forest from Beach Pond to the Quinebaug River. Mills began to dot the banks of the river and its tributaries as early as 1711. Nearly every brook in the area has some remnant of the many mills that once graced the forest preserve.

Like many other small New England farming and mill communities, progress and technology became their enemy, and soon the small village

of Pachaug was on the downward slide. By the Great Depression of the early twentieth century, the village was nothing but overgrown roads and crumbling homes. The mills, long dormant, had also fallen into disrepair and were soon consumed by the ravages of time and nature. All that remained among the forest were the ghosts that still hold their vigil to this day amid the ruins of what was once their home.

There is a section of the forest called Hell Hollow along a road and pond of the same name. The name is not necessarily derived from the demonic forces that thrive in the area. The settlers named many parts of Connecticut with prefixes like "devil" or "demon," as the area gave them the feeling that there were supernatural forces at work. In the case of Hell Hollow, the land was rocky and poor. Farming was brutal, and the area was prone to flooding. These conditions made the settlers' toils a living hell. Such names have carried on through history. If they are haunted at present, it only adds to the mystery of the locale. A rock formation known as Devil's Den can be seen northeast of Hell Hollow Pond, on the southwest side of Flat Rock Road along the Quinebaug Trail. This may not be of ghostly significance as much as it tends to reiterate the fact that the settlers were probably a bit superstitious.

Visitors to this patch of the forest have witnessed a dark entity that rushes out of the woods directly in front of them. The dark being is reported to be about fifteen feet long and hovers a few feet off the ground as it makes its way across the road. Hikers and hunters alike have given testimony to the strange fiend that lurks in the dark bowers of the forest. Many also get a fearful feeling of being watched while traversing the trails of the Hell Hollow section of the forest.

Another haunting in the Hell Hollow area is that of an Indian girl. In the late 1600s, an Indian woman was slain by English soldiers near the present Hell Hollow Road. Since then, her vengeful screams of murder and brutality have saturated the air in a tormenting aria that eerily replays over and over. The screams send even the bravest hunter on his heels for more hallowed ground. The local hunters will not venture far into that area, according to the few I have talked to. They wished to remain anonymous for fear of ridicule, but as one said, "When you hear that piercing scream come out of the woods, no one cares what anyone might think. Your hair stands up on the back of your neck and you are out of there!"

The ghost of a colonial soldier still makes his rounds at a section along the decrepit Breakneck Hill Road. Locals have encountered the vigilant spirit many times over the years as it marches back and forth along the side of the

A sharp corner on Breakneck Hill Road where the ghost of a colonial soldier in a tattered uniform still holds sentry duty.

gravel and tar lane. Some have actually almost hit the wraith as it crossed the road, still on eternal duty. Author David Trifilo encountered the ghostly soldier once while traveling along the thoroughfare. He wrote of his experience in his book, entitled *The Hauntings of Pachaug Forest*. The author was rounding a sharp bend of the road when he encountered a threadbare colonial soldier carrying a long musket over his shoulder. The entity marched into the road right in front of Trifilo. When he hit the brakes, the ghost vanished into the void. The narrow road winds and twists through the forest, making it very difficult to exceed the twenty-five-mile-an-hour speed limit. Because of this fact, the sightings of the soldier have been frequent over the years, as those who witness the wraith have plenty of time to verify to themselves what they had encountered. Lauren Neslusen of Quiet Corner Paranormal has heard of others who have been startled by the ghostly guard as it crossed the road in front of them. Motorists have actually driven through the specter. Some have stopped for a moment to reflect on what they just encountered, while others do not stick around for a second meeting.

The ghost of this soldier has been witnessed for centuries. The first recorded sighting goes as far back as 1742. The description is the same as the present-day witnesses' accounts. The spirit is dressed in a tattered uniform

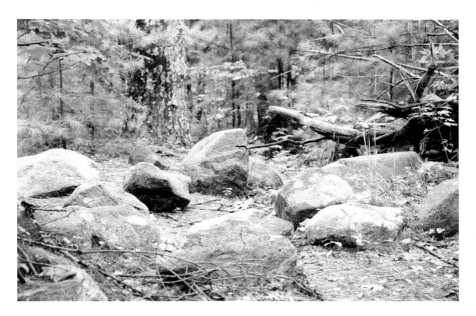

The remains of Maud Reynolds's grave just off Hell Hollow Road.

and holding a long musket slung over his right shoulder. He marches silently and dustily along the bend in the road, sometimes crossing as if looking for something on the other side. The date of the first sighting places him well before the American Revolution. Perhaps he is a remnant of King Philip's War (1675–76) or Queen Anne's War (1702–13), which was the second inter-colonial war between France and England. Some claim he is from the French and Indian War, yet that conflict took place from 1754 to 1763, several years after the initial appearance of Pachaug's ghostly sentinel.

Another spot of spectral relevance is an area of the forest called Maud's Grave. There are many discrepancies as to where the grave is located. Some claim it is in a small path next to Hell Hollow Pond, while others have put it in the woods off Cedar Road. There are numerous legends regarding the ghost of Maud.

One account states she was a young girl who mysteriously died at the age of six. Her ghost is seen near her grave, which is a pile of rocks near the pond. Another account states that she was Maud Reynolds, daughter of Gilbert and Lucy Reynolds, who had a small farm on Hell Hollow Road. Maud died just three months before her second birthday. A doctor stated the cause of death was diphtheria, which ran rampant in the nineteenth

century. The throat tissue would swell, followed by heart failure and death. Maud had reportedly choked on a piece of apple. Her parents found her on the morning of October 12, 1890, with the apple by her side. Having no photograph or portrait of the girl, they preserved the apple in alcohol because it had the impressions of her baby teeth in it.

She was the third child of the Reynoldses to die within a few years. She was not buried in the family cemetery. For some strange reason, she was buried across the road from the now decayed family plot. Local legend tells that the mother was so taken aback by the death of her daughter that she buried her on a rise close to the home where she could see the cross that marked Maud's grave. It is in this spot that her ghost is seen, perhaps trying to find her family or wondering why she is not at rest with her brothers. No one has an answer, as she has never spoken.

There is a spot in the woods off Cedar Road where a foundation marks the site of a farmhouse. There is also a cement slab that has the inscription "Maud Mallone 1647–1654." It is barely legible, and the slab appears to be made of cheap concrete. This looks more like a campfire prank than an actual grave. Most people have taken this for the grave of Maud. Several trips to the Pachaug Forest, along with interviews of others who have investigated the area, have turned up these interesting facts about the haunts. Pachaug Forest has a lot of history still rambling amid the thicket that is ever ready to let you know that the ghost town is still tenanted by, well, ghosts.

THE LEATHER MAN

Connecticut is known as the land of steady habits. No character in the history of the Nutmeg State has been known to uphold that tradition more than the legendary folk hero called the Leather Man. No one really knew the actual identity of this famous vagabond who roamed the region of Connecticut from the Connecticut River to the Hudson in New York. In his thirty-year tenure, the Leather Man rambled continuously throughout western Connecticut and eastern New York State. In his last several years, he was known to travel in a clockwise 365-mile circle. Every thirty-four days, he would be back at the same place. Townsfolk could set their clocks by his arrival. Some accounts claim he was Jules Bourglay, a native of Lyons, France. This particular story associated with his strange wanderings in this part of the world lends credence as to why he wore a heavy leather wardrobe.

According to the legend, Jules Bourglay fell in love with the daughter of a wealthy leather merchant. As Bourglay was of a lower class than the lady he sought to woo, her father forbade their union. In time, the father warmed up to Jules and granted him a test to prove his love and perhaps ability to improve his status. He gave Jules a position in his firm. Bourglay proved to be successful in business affairs and was soon given more decision-making roles in the enterprise. At one point, the leather market made a sharp rise, and Jules quickly invested most of the company's capital into the trade. The market quickly plummeted and left the firm nearly bankrupt. Having lost the respect of his love's father (not to mention most of his money), poor Jules lost his senses and was soon institutionalized.

He somehow escaped the institution and made his way to the States, where he was first seen in April 1858 in the town of Harwinton. Dressed from head to toe in a heavy leather hat, large overcoat, thick trousers, shoes made from wooden soles with leather tops and a large side bag for carrying his possessions, he would walk his route, sleeping in caves, stopping in towns for food and then continuing on his way. He never worked or performed chores for money as other hobos did. He never took any currency either— only a meal and, when offered, tobacco and matches. It was later discovered that he had smoking pipes stashed in many of the caves he used for shelter along his course.

The book *Historical Accounts of a Connecticut and New York Legend* by Dan W. DeLuca is a chronological compilation of news articles and stories of the Leather Man's life as he wandered from town to town. One reporter for the *Deep River New Era* claimed that the Leather Man told him his name was Randolph Mossey. This was never substantiated, though, as the people who came in contact with the wanderer never acknowledged him by that name.

Leather Man never spoke too many distinguishable syllables of the English language to anyone. His form of communication was in gestures and sometimes grunts in French, yet he became quite the icon in Connecticut. His arrival into town was so prompt that people would put plates of food on their doorsteps for him to eat. Leather Man rarely entered a home or ever accepted shelter in a barn or outbuilding. The many caves he lodged in lace through the Connecticut and New York countryside and are now revered as attractions for the adventurous who retrace his steps through the region. He would silently dine upon the bearer's doorstep and then be on his way. Once, he made his usual stop at the Fenn Farm in Plainville. Mr. Fenn, not having had contact with the drifter, answered the door and asked, "How are you?" Leather Man quickly drew away from the threshold and departed, never to return to their doorstep again.

As time went by, it became an honor to have the legendary figure stop at one's doorstep for vittles. The townspeople actually competed for the opportunity to have Leather Man feast upon their cooking. At South Chippens Hill School in Bristol, the teacher held a Leather Man Day, where the student with the highest honors in the class was given permission to offer the traveler something for his journey. On that day, the children would stand outside in a line, and when the rover came by, the honor student would step forward and silently present his offering to the icon. Leather Man would gently take the gift, nod a silent thank-you and resume his course of travel. Some say they could hear him coming from a good distance by the squeaking

of his clothing. He truly became a folk hero to all and was very rarely ever taunted or provoked. In fact, ten towns along his route did not consider holding him in violation of the Tramp Law passed in 1879.

He never sought repair for his clothing, always mending it himself with pieces of boot leather he would find, which means he was probably efficient in leatherworking. He was known for his appetite, as records from one store indicated he procured a loaf of bread, can of sardines, crackers, pie, two quarts of coffee, a gill of brandy and a bottle of beer. Where he obtained the funds to pay for this, or if he actually ever needed to acquire any money, is forever a mystery. As to his timely circuit, the Darrow family of Shrub Oak in Northern Westchester, New York, kept an account of the Leather Man's visits to the hamlet. From 1858 to 1889, he passed through town every thirty-four days on the dot. This he did 360 times for thirty-nine towns in his thirty years of roaming the countryside.

In the winter of 1888, he was found freezing in the snow. Officials arrested him out of humanity and took him to a Hartford hospital, where he refused to stay. After he was examined, the doctors deemed him sane but suffering from some frostbite. He gave them a name of Zacharias Boveliat. Only then did the Leather Man slow down. His age, coupled with mouth cancer from heavy tobacco use, protracted his schedule. Leather Man died on March 24, 1889, in a Saw Mill Woods cave in Sing-Sing, New York. Some records say it was from a fall, but popular consensus states that it was from the cancer he refused treatment for. In his bag were found leather-working equipment such as scissors, awls, wedges, a small axe and a prayer book written in French. An Englishman named Sampson Fiske-King Bennett who claimed to have spent time with Bourglay in Ninevah, Paris and Ur paid for his burial in Sparta Cemetery in Westchester. A post marked the burial site until the 1930s, when the Westchester Historical Society placed a proper stone over the grave. The stone reads "Final Resting Place of Jules Bourglay of Lyons, France 'The Leather Man' who regularly walked a 365-mile route through Westchester and Connecticut from the Connecticut River to the Hudson, living in caves, in the years 1858–1889."

One of the first mysteries of this saga is that no one really knows who the Leather Man was. There is no record to indicate that he was a man named Jules Bourglay or the other aliases he was known to be. In fact, most accounts lean toward the contrary. So who was he? He never spoke, and when asked questions pertaining to his identity or when confronted, he quickly shied off into the distance. Another mystery is why he chose to wander the same circuit for so many years. Conceivably, it could have been for reasons of a

guaranteed handout. Those who knew him would feed him, and he had gained much respect from the towns he passed through.

Why, then, did he always sleep outdoors and never once take the kind gesture of a warm bed? These are among the many unanswered questions the Leather Man took to his grave. One more question is why this story appears in a book on haunts of Connecticut if he is buried in New York. The Leather Man actually spent most of his time in Connecticut, for one, but the other reason is far more interesting. Many of the caves he dwelled in are allegedly haunted by the tramp, especially the one in Watertown called Leather Man's Cave. Many still see the glow of his fire from the cave and have even heard inaudible grunts coming from the perimeter of the cave. Some have heard the creaking of leather pass by them as they stood near the entrance. His ghost has been reported there as well. Some claim to have seen a misty figure guarding the entrance of the fissure. This is not the only grotto where the Leather Man still makes his presence known.

After his death, many believed he had left hidden treasure in some of his caves. Prospectors went in search of his shelters in hopes of finding the loot they believed was stashed away. This led the superstitious to believe that his ghost protected many of his shelters. In one case, Clematis Sorrel was searching the Saw Mill Woods cave for lost treasure when a sudden eerie wind extinguished his torch. He then turned to see a glowing figure lighting a pile of kindling. The shade rose slowly and gave an angry motion to the frightened Sorrel to leave at once, which he did, barely touching the ground as he fled swiftly to the safety of his home, never looking back. There are many similar accounts among the crevices where the Leather Man slept, but after he had passed, many look-alikes began to flood the region, cashing in on the original's legendary status. Some even went as far north as Massachusetts.

The following is from LeRoy Foote's "Caves in the Litchfield Hills" in *Lure of Litchfield Hills Magazine* in December 1952:

Considerable inquiry was made concerning him and in time he became accepted for what he was, an itinerant who asked for food and wished to be left alone. His wishes were acceded to but some residents, more curious than others, took the time to learn more about him. It was found that he had a circuit of 365 miles that he covered every thirty-four days and slept at night in caves. He traveled in a clockwise direction, never once retracing his steps. From Harwinton his route took him to Bristol, Forestville, Southington, Kensington, Berlin, Middletown and south along the westerly side of the

Connecticut River to the shore towns, thence westerly to Westchester County in New York State and without crossing the Hudson, turned easterly into Connecticut near Ball's Pond. From Danbury he went northerly to New Milford, to Roxbury, Woodbury, Watertown, Plymouth and back to Harwinton, thus completing his cycle.

Foote, who became infatuated with the mysterious character, researched and retraced the Leather Man's trail for many years, collecting artifacts owned by the legend along the way. Others have tried to piece together the puzzle of this enigmatic rover with very little success. His mission and true identity may forever be a lingering mystery in the annals of Connecticut history. If you find yourself out by one of the many shelters the old man called home and see a visage covered from head to toe in patches of leather sewn crudely together, do not be afraid to ask a question or two. But, remember, it must be in French.

WINDHAM TEXTILE MUSEUM

Beverly York is no stranger to history. She retains a position as an important staple of the Connecticut Landmarks, where she is curator of several buildings owned by the organization. She is also no stranger to the world of the paranormal. Some of these landmarks still hold quarter to past revenants that amble among the chambers they knew in life. Beverly has seen and heard some of these ethereal characters and was not afraid to share some of her experiences with Arlene and me, especially a few occurrences regarding the Windham Textile Museum.

The Windham Textile Museum is composed of two historic buildings that were erected in 1877 and are situated in the massive mill complex that once housed the Willimantic Linen Company, which later became the American Thread Company. The mill ran from the 1870s until 1985, when it finally closed.

Workdays in the mills were long and harsh. The buildings were cold in the winter and sweltering hot in the summer. The days lasted from twelve to fourteen hours, and the machines were dangerous to the less than careful. Many workers were killed or maimed by the unforgiving apparatus used in early industry. The factory owners paid their employees with company scrip. This way they could set up stores for the workers to shop at and recoup their wages back—at a profit, no less.

From the moment the society acquired the property, strange occurrences began to vie for the employees' attention. As restorations were about to begin, they noticed a large safe that needed to be opened. No one had the

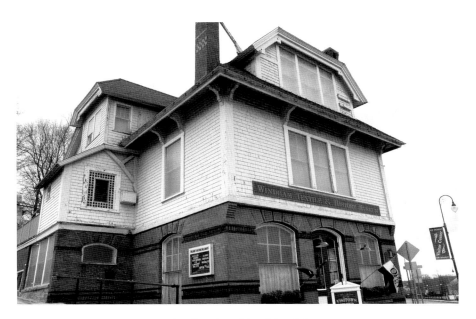

The Windham Textile Museum is still active with spirits of the past.

combination to open the massive door, so a locksmith was called in to assist the society in gaining access to the inside of the structure. After examining the lock with a laser light, the locksmith quoted a price of $300 to crack the catch. They had to put the idea on hold until funds could be properly appropriated for that particular task. Apparently, the spirits of the factory did not want them to spend such a cache in that manner, for when Beverly entered the building the next morning, she was quite astonished to see the safe door swung wide open.

Another incident left her quite perplexed. She explained the situation to us as such:

> *There was this one door that was a pain for me to open and close. It was a closet where all the light switches were, and the lock would push upward at the top of the door. Not only was it hard for me to reach the lock, the age of the building had caused a lot of settling and the door was slightly misaligned. When I was there, I never shut or locked that door. One evening when I was closing up, I went to turn off the lights and the door was closed and latched. I was the only person in the building that day and back then, the only person with a set of keys to the old mill. Yet, the door was locked tight with the latch pushed upward.*

How a latch can fall upward is one of the great mysteries of the paranormal that every investigator would like to take a crack at solving. This was not Beverly's only encounter with the invisible yet playful spirits of the museum.

Another series of uncanny occurrences that left Beverly a bit bewildered was the way the spirits played with the paperwork. On several occasions, very important and time-sensitive documents disappeared from her desk without a trace or clue. She would search through every sliver of paper looking for what she knew should have been in plain view. After a while, she would give up and lock the doors for the night. In the morning, she would find the documents at the top of the paper pile on her desk. This happened several times.

Others have felt cold spots that seem to follow them about the museum. The third floor houses a library that was once available to the workers. It is called the Dunham Hall Library after the founder and owner of the mill, Austin Dunham. It opened on March 2, 1878, as Willimantic's first library. Factory owners felt that their workforce should be educated. To them, this was an investment, as many spoke various languages and communication was an issue. Workers were given their breaks to take in the library and read or study. It was available to them at different hours after work, and classes were held in the room to better educate the workforce. (This is quite different from the normal scenario of early factories and even those of today.) Strange noises can be heard when the place is empty, as if someone is shuffling around looking for a book among the shelves.

The second floor is host to a feeling of being watched while touring the museum. This floor contains permanent exhibits such as a re-creation of the company office, a typical mill manager's lavish Victorian home and the millworker's meager quarters. Even the most hardened skeptics cannot help but feel uneasy when exploring the exhibits on that floor.

Our visit to the museum was most informative and intriguing. The staff was very much into the ghostly goings-on in the two buildings. Curator Brooke Shannon told us of some of the findings within the museum. Two women once followed a person into a room. When the tour guide asked them where they were going, they stated that they had seen a strange figure walk into the small room. Upon investigation, they found the room to be empty, save for themselves. "There is a spirit of a child in this gift shop. She has been witnessed in that back corner by the books," Shannon informed us. Paranormal investigator Joe Galant took a few photos of the small mill next to the museum that at one point served as a fire station. He was shocked to see the image of a little boy looking out of one of the windows. Child

The window at the Windham Textile Museum where a ghostly face was photographed.

labor was common in those days; in fact, at one time child labor made up 55 percent of the workforce in Rhode Island. Children were used to long working days from farm life, so it was an easy transition as far as the hours of labor time was concerned. Children could run simple machinery and were small enough to scurry under the looms when they became tangled and untangle the threading before the loom came back at them. If they were not quick enough, the result was very grim.

A neighbor inquired to Shannon about the tenant who stayed up all night occasionally looking out the third-story window where the library was. Shannon relayed to the startled fellow citizen that the building is a museum and there are no residents occupying the structure—at least not living ones.

It can be certain that energy still lingers among the artifacts that are now an important part of our manufacturing history. Maybe a few spirits feel that their contribution to that history should not go unnoticed as well.

FROG POND AND BRIDGE

Frog Bridge in Windham, at first glance, may appear to be a whimsical piece of artwork, but it is actually a memorial to the beloved amphibian that mankind seems to adore. The bridge sits at the corner of Main Street just before the Windham Textile Museum. The frogs were sculpted by an artist named Leo Jensen between 1999 and 2001 in commemoration of the incident that made Windham famous. The frogs sit on giant cement spools, as Windham is also known for its historical significance in the thread industry. The bridge stands as a monument to an event that took place near the center of Windham at what is now known as Frog Pond. This next account has a place in New England folklore that is as perennial as the seasons. Much of the colonies took delight in printing the dilemma that befell the good people of Windham on a dark and murky summer night. One such printing was called "Lawyers and Bull-Frogs." According to the 1836 writing of John Warner Barber, the incident took place in July 1758. Another recorded writing of the incident appears in a letter from Dr. Stiles in June 1754. A woman named "Old Sinda" related the account to George Webb, Esq., of Elizabeth, New Jersey, when he was a child. Apparently, Dr. Stiles gained possession of the letter at some point. Old Sinda was the wife of Colonel Dyer's body servant, Jack. Although the dates contrast by four years, the story remains largely the same. Read on and let the unpredictable spirit of nature fuel your imagination with this next account.

The inhabitants of Windham had finally lain down to rest on this particular evening when the silence of the summer night was shattered by

The Frog Pond in Windham, where the famous bullfrog battle took place.

a most unearthly disharmony of wails and screams. The chimes had just passed the midnight tolling when the townspeople were summoned from their slumber by the shrieks that freighted the air above them. The French and Indian War was still in full force, and the villagers at first feared the worst: an Indian attack. Many of the men from the village were already off fighting the campaign, making their fears deepen even more. The noise persisted with no physical beings pressing upon the township. Other members of the frightened throng surmised that judgment day had come and began hiding under their beds or running frantically in the streets.

As the terrified citizens huddled in fear, some of the din began to take on a more linguistic character most peculiar yet familiar to their ears. The names of Colonel Dyer and Elderkin, two prominent citizens and attorneys, echoed through the night air, sending even more panic through the hearts of the confused multitude.

Those who had concluded it was the rants of Indians loaded their muskets and wandered into the darkness to meet their foe. The brave souls, bent on protecting their "kin and kith," meandered up the hill bounding the town to the east. It was there that they halted, daring not to march forward into an ambush, as the darkness had completely stunted their vision.

Surely they would not wander into the blackness with no confirmation of the whereabouts of their enemy, whose cries seemed at that point to whirl around them from all compass points.

The terrified citizens held fast until the dawn's rays brought abatement to the racket. The early morning light at once gave them an opportunity to see what the din was. Many of the villagers joined the militia that had camped out on the hill overnight, and together, they cautiously sallied forth toward a millpond that lay about three-quarters of a mile east of the village. As they neared the place where the millpond was located, a most remarkable sight awaited them. Whether the discoverers of the commotion were amused, embarrassed or just outright relieved by what they beheld has never been divulged, at least not on an individual discourse. There in the dried-up pond were some say hundreds and other accounts thousands of dead bullfrogs that had obviously battled all night for the remaining puddle that they needed for survival. On both sides lay the defunct combatants, whose cries of "Colonel Dyer, Colonel Dyer!" were offset by those that took a stand on the opposite side of the waterhole screaming, "Elderkin too, Elderkin too!" It was as if the frogs of Windham were blaming these two men for their

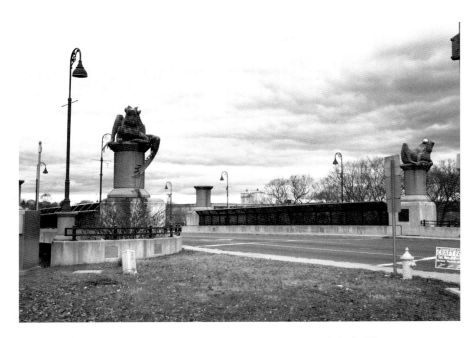

Frog Bridge in Willimantic, commemorating the famous battle of the bullfrogs.

plight and, thus choosing sides, began a heated battle that persisted through the night. These cries, in the silence and absence of our modern noises and distractions, carried easily across the fields and forests and into the ears of the people of Windham.

Perhaps the frogs were not way off on their reprimands. It appears, according to record, that Colonel Dyer had drained the pond that June in order to repair the dam. Dyer, Elderkin and a man named Mr. Gray were among those who saddled up and rode toward the crest of Mullien Hill to find the source of the racket.

From that moment on, the waterhole was known as Frog Pond, and the town was written into history as the place where multitudes of frogs battled on that hot summer night so long ago.

THE MORIN HOUSE

It is unusual that you are reading this story, as private residences do not usually become an aspect for publicity. This case is quite to the contrary, as Lori and Marc Morin feel that their experiences would serve to help those who may be in a similar haunted situation.

Arlene and I came into the picture in 2007 when Lauren Neslusen of Quiet Corner Paranormal contacted us for assistance in a case she had been working on. Arlene and I were more than happy to lend our time and expertise in an investigation. The home was built in 1800 and, according to deeds and records, has had only eight owners over the last two centuries. The Morins purchased the home in 2001 from the previous owner, who had possession of the property for a mere four months (we can only wonder why) before selling out. Before that, Robert and Mildred Reynolds had lived there for about fifty-two years. The property was used as a cattle farm. In fact, the room where the cows were milked still remains as part of the large barn. There is a chalkboard with writing on it of the last milking that took place many years ago. Both the main dwelling and the barn are occupied by some of those previous owners—in spirit form, of course.

Lori and Marc both experienced paranormal occurrences on several occasions. One evening, Lori was walking into the kitchen when she suddenly saw the upper half of a young woman with her hair in a high ponytail standing near the table. The apparition slowly vanished after a few moments. She witnessed the same young woman near the chicken coop, and just as in her previous sighting, the ghost was visible from the

waist up. They both have heard noises coming from the room that is now a laundry room off the kitchen. Upon inspection, they found nothing out of the ordinary. They have heard the voices of a man and a woman while working in the barn, and one evening when Lori was in the barn looking for something, the voice of a man mimicked her not once but twice. Marc took several photos of strange forms within the barn where voices had been heard. Their daughter was always talking about a friend who visits her named Manda. During our research, we found that a woman named Miranda lived and died in the house.

They have heard voices in what was the spare bedroom, and Lori was napping one day when something pulled the blanket from the couch just outside the spare room. They have also witnessed the apparition of another woman in that room. It would be safe to say that we were very interested in an opportunity to investigate this farm.

Our first investigation left us with no evidence of what they had experienced. We stayed in contact and would eventually investigate the Morin home several more times. Our second investigation proved they were truly experiencing paranormal activity.

We made this second attempt to contact the spirits of the house with fellow Paranormal United Research Society investigators Rich and Ally Allarie. We set up our cameras in the specified rooms and barn and let the night begin. Arlene used the tarot cards and rods to field and answer questions, while the cameras and recorders captured the moments in hopes of recording something paranormal. During our investigations, we employ the use of dowsing rods to find energy and tarot cards to field questions. These ancient devices are coupled with modern cameras, recorders and various other equipment that help discern the normal from paranormal. As stated before, paranormal investigations are much like fishing. A good tackle box and wealth of knowledge of the place in question will always obtain better results.

The night went smoothly, and we did not experience or witness any major activity. We set up a camera in the spare room and decided to hold a vigil in the barn. When we played back the video in the bedroom, it showed the lights dim and the EMF meter start to blink frantically, and then the camera went fuzzy. Something translucent was standing right in front of the camera, as the light on the meter was blurry yet visible through whatever was in front of the lens. This went on for about thirty-five seconds before the camera view became clear, the lights went back up and the meter stopped. This strange event transpired about ten minutes before we returned to the house from our vigil in the barn.

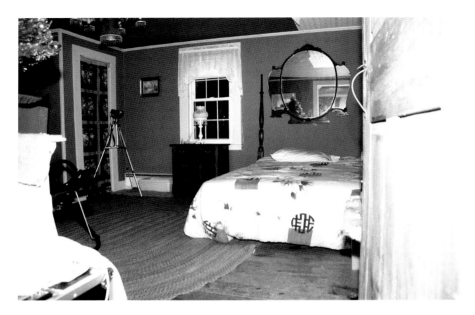

The spare room of the Morin home, where the ghosts seemed to have an aversion to Arlene and Ally of Paranormal United Research Society playing with the cat.

We also recorded EVPs from the spare room. Arlene and Ally were playing with a cat that was once nursed in that room. During the whole time they were letting the cat chase a red beam of light from the non-contact thermometer, the audio recorders were recording. As they laughed and joked with their new feline friend, a female voice came through telling them to stop, go and mocking their laughter. It was obvious someone did not want them playing with what they may have considered their cat. They did not hear the angry voice at the time, but when we played the recording back, it was very clear that someone—or something—was in the room with them for those few minutes.

During our investigation, I asked, "How many children did you lose in their infancy?" Much to our surprise, we received an answer that stated, "None, they grew."

In the barn, we received a few EVPs as well. When Arlene, Rich, Ally, Lori and I first entered the barn, we thought we heard a voice. I called out to repeat what we thought we heard, as we did not clearly understand what was said. When I replayed the recorder back, a whispery voice clearly says, "Go!" We also captured an EVP that simply states "stop" and nothing else. All of these can be reviewed by going to www.nepurs.com on the investigation page.

During our next visit, we were able to capture more evidence that the Morin house has permanent guests, although it was not as intense as the previous visit to the farm. We have since become friends with the family and enjoy spending time chatting. Lori once worked as a waitress for the haunted Stagecoach Tavern in Chepachet, Rhode Island, so she is no stranger to the paranormal. A lot of the activity seems to revolve around the farm animals and pets of the house. Incidentally, Marc has his own home improvement business and Lori makes special custom plaques for gravestones that are high quality and last forever. They are extremely affordable as well. One of her most popular orders has to do with pet markers. Perhaps it is no coincidence that this little farm holds spirits that are attracted to the animal kingdom.

THE BRADLEY PLAYHOUSE

In the heart of downtown Putnam sits the historic Bradley Playhouse. It is a charming theater where live performances fill the air with magic. The historic playhouse is always beaming with excitement as live actors re-create scenes born of imagination and ingenuity. Guests get to leave their world for a while and join that of the actors on the stage. There are also a few spirits that eternally revel in the glamour of this noted showplace.

Ransom Bradley fulfilled his dream on January 29, 1901, when the theater, designed and constructed by local architect Charles H. Kelley, opened its doors to the anticipating public. Vaudeville shows, silent movies, sound movies and live performances have graced the stage ever since. The theater was victim of three fires, two in 1914 just fourteen hours apart and one on December 9, 1937. The Bradley had a specially designed asbestos curtain that would drop in front of the stage, thus containing the conflagration to that area alone. The curtain, one of three known to have actually served its purpose, worked, and the building sustained minimal damages. Each time there was a fire, the theater was expanded and improved upon. It opened after renovations on December 25, 1937, showing first-run movies. The name was later changed to the Imperial and ran under that designation until 1985. The name was changed back to the Bradley Playhouse with the inception of the Northeast Repertory Company bringing live theater back to its stage. The Bradley Playhouse once held one thousand guests, but that has since been reduced to a four-hundred-seat capacity due to renovations, larger seats and other modern comforts.

It is always showtime for the spirits of the Bradley Playhouse in Putnam.

The Bradley is presently under the auspices of Theatre of Northeastern Connecticut (TNECT), an amateur community group that produces seven shows a year along with various fundraisers. The building houses a few hair-raisers as well. Strange noises echo through the theater, often causing the actors to take a second look about the hall. Seats are known to move as if someone is either getting up or moving them to get through an aisle. People have seen shadows pass behind them, some lean forward to give the audience member extra passing room, yet when they turn around there is no physical being to create the mysterious shadow.

Patricia Green, business manager for the TNECT, took me on a tour of the playhouse, relating all the stories she had heard over the years. During one particular play, a coffin was used as a prop. Lying on top of the coffin were a sash and a rose. Just before showtime, the rose suddenly disappeared from the coffin lid. As it was a very important prop for the upcoming scene, cast and crew searched frantically for the flower but came up short. It was decided that until another rose could be procured they would have to improvise with another prop. When they carried the prop over to put on the coffin, the rose that had been missing was once again in the exact same spot where it had been originally placed. No one could have taken it or replaced it as the coffin had at all times sat in plain view of the cast and crew.

Of all the happenings at the theater, the most unnerving occurrence is the appearance of the Lady in Blue. The phantom figure, dressed in a flowing blue dress, is often seen in the balcony by the performers during rehearsals. The spirit is dressed in 1940s' style clothing and, according to those who have witnessed her, does not care for any plays other than musicals. She is seen to become very agitated and leave. Staff tends to believe she may have been a wife of an owner or a theater employee at one time. They have also seen the figure in the backstage mirror.

Two children who were practically raised at the theater have seen a few of the resident ghosts. Patricia's granddaughter once saw a man she called the "frogman" crouched on the stage. A son of a playhouse employee once waved and said "hello" to what he described as a woman in a white dress he saw while in the balcony. No one else saw her, but he insisted she was there.

Patrick Pollard, a volunteer at the playhouse, has heard noises he cannot explain. Many nights he would be working alone in the building and hear what resembled footsteps creaking along the wooden floors in the auditorium. He knows all the creaks and groans the building emits, but there were some he could not put his finger on.

The building is wispy, and open, and has lots of elements to it, tin that creaks, winds that howl across the stage, when the lights warm up, they begin to creak. You can become an empath, and absorb it or you can say "I know what this is" but there have been times I have been here in the middle of the night by myself, working on lights. Everything is dark because I am focusing lights way in the back and you start thinking about it and then all of a sudden you feel like you are glowing because of that feeling you get. It could be lots of things.

Patricia has also heard the footsteps. Both Patrick and Patricia demonstrated how the floors have let out an unmistakable groan when someone is moving across them. Other staff members, along with Patrick, have had the hair on the backs of their necks and arms suddenly stand on end. He explained how it could be just the fact of being in an old building where so many stories have circulated over the years—or something else.

One night, some of the stagehands were working on a set and there were tools and debris all over the stage. They were talking about the ghosts and Patricia said, "There is no such thing as ghosts." At that moment, a screw gun flew off a paint can and onto the floor. Pat stated it could have been placed there haphazardly, but it was a strange coincidence that it would fall at that moment.

A man came in who was new to the theater and had never heard any of the ghost stories. He sat down in one of the seats. A few moments later, the seat next to him folded down, yet there was no one who reclined in it. He then told Patricia that he could feel his father's presence next to him. Another staff member walked across the stage on her first day at the Bradley and immediately felt as if something were following her. Performers have had some invisible being rest a hand on their shoulders while on stage.

Another unexplainable event involves a heavy safe that was in Patricia's office. It is customary when the office door is closed to wait until the person inside is done with their business before entering for any reason. A few staff members knocked on the door several times, but no one answered. Finally, they agreed that the door was closed with no one inside. Patricia tried to open the door, but it would not budge. She was finally able to open it a crack only to notice that the safe had been pushed in front of the door. No one could explain how a safe with no wheels managed to slide across a carpet and block the entrance. The door is the only way into and out of that office, so no one would have been able to push the safe into that spot and close the door behind. As for the energy that may reside in the playhouse, everyone will attest that it is friendly, positive and harmless. It may also have a lot to do with those who work there. As Patricia stated:

There is so much activity going on, not only spiritually but physically. There are about 120 live bodies that bounce through here on a regular basis; the members, cast members and core group all with these incredibly dominant personalities that carry their energies around and bounce their creativity off of one another.

There is a lot of energy from the people who are alive in the playhouse that charges the place where perhaps other energy may feel welcome and part of the scene. Whatever the case may be, normal and rational occurrences or paranormal, there is definitely a spirit or two in the Bradley Playhouse giving an eternal encore performance.

A Brief Collection
of Ghostly Grimoires

Eagle Hose & Hook & Ladder Co. #6

Heroes are interminable. There are such heroes in every city and town. They hold regular occupations and can be seen shopping or walking in the park, but when called upon, their bravery rises above any measurable scale. Many of these people are volunteers within the community they reside. Volumes of praise are not enough for their undying pledge to the township they serve. In some cases, these champions of the people are compelled to protect the public long after they have passed on themselves. There are many reports of public service buildings being haunted. At the Eagle Hose & Hook & Ladder Co. #6, there seems to dwell such a spirit that remains within the firehouse as an eternal guardian of the people still on duty.

The company's proud beginnings were born of a tragic fire that started in the local opera house on Main Street in 1871. This made the town realize the need for an organized fire department. On August 24 of that same year, a handful of prominent young citizens formed the city's first official fire department. They had planned to call the division Ansonia Fire Co. #1. The first captain of the twenty-five-man crew was F.L. Clemens. Funds were limited, and the search for affordable apparatus was on. They soon located a reasonably priced parade hose carriage from Newark, New Jersey. William Williams built the carriage in 1859 for a New York City fire company that disbanded in 1865. It traveled from New York to New Jersey, eventually

making its way to Ansonia. The apparatus bore the inscription "Eagle Company No. 6" on its side. The removal and replacement of the logo would have been laborious and costly and also would have destroyed the beauty of the carriage, so the men decided to name the company after the inscription on the side of the wagon. The company still owns that same carriage (now renovated) and carries the honor of being the only fire company named after a parade carriage.

A hook and ladder carriage was added in 1879, and the company changed the name to the Eagle Hose & Hook & Ladder Co. #6, the same moniker the company boasts to this day. From 1871 to 1914, the company used manpower and horses to serve the public during emergencies. Main Street, along with every other street, was not paved. Mud in the warm months and ice in the colder seasons made it an arduous task to transport the apparatus to fires. Once at the scene, the cumbersome and weighty ladders burdened the already taxed firefighters, making the endeavor of putting out a fire more exasperating.

This changed in 1914, when the department purchased a Maxim fire truck powered by a ninety-one-horsepower, six-cylinder engine. A few years later, it purchased a Seagrave ladder truck, bringing to an end the cumbersome apparatus of the previous century. Many noted citizens served on the department. Ansonia's first mayor, Arthur H. Bartholomew, served as captain. Later mayors Franklin Burton and Lockwood Hotchkiss also served among the ranks of the ever-growing company. Today, one hundred dedicated members selflessly serve the public at the hose company.

The company has had three homes since its inception in 1871. Its humble beginnings hail from a building on First Street before moving to Main Street in April 1879. The present two-story house was erected in July 1904. The basement was originally a canal used to supply water to the local factories. As the tides of progress changed, the canal was no longer needed, and the lower section of the building was turned into a beautiful room. This room is now a museum of sorts for the fire company, ornamented with memorabilia hailing the company's past. The space, now called the Canal Room, moonlights as a function room for special events the fire company holds from time to time. It is also reported to house an unseen tenant. People in the building have heard strange noises emanating from the basement when they are certain no one is down there. Items are also moved from one place to another, and voices can be heard echoing through the room.

It seems that whatever, or whoever, is there acts up mostly when there is a minute audience. Many occurrences happen when there is but a single

occupant in the firehouse. The company is a volunteer fire department, so many times the building is scarce of the living. Perhaps when there is more than one person in the building, the strange noises are attributed to a living person. The occurrences happen largely in the Canal Room and the second floor of the firehouse. Maybe it is a former member who has some sort of personal attachment to the room by way of some of the mementos that adorn the architecture.

Whoever it is certainly feels attached to their duty. There are many pictures and names of the firefighters that once were part of the company. If it is one or more of these heroes, then they are probably just there to make sure the company still maintains the top standards it has been known for throughout the years. If this is the case, it can be certain that there is always someone on watch at the Eagle Hose & Hook & Ladder Co. #6.

DOWNTOWN BRISTOL: LIGHTS ARE BRIGHT BUT NOT NECESSARILY FROM THE LAMPS

Downtown Bristol is known as a ghost town, but not because tumbleweeds roll with the desert wind that whistles an ominous tune through the streets. Downtown is quite alive with the hum of everyday life. It also holds much of the long-gone revenants of the past within the walls of the more modern architecture that sprang up in the ebb and flow of a great flood in 1955.

Although you would never have guessed by looking at the town today, Bristol was once an isolated woodland barren of any human existence. Once part of Farmington, it was known as the West Woods until the first settlers arrived in 1720. In 1742, they became the New Cambridge Parish. This lasted until 1785, when they joined the New Britain Parish and became a town called Bristol. The Pequabuck River was ripe for industry, and many factories sprang up along its banks. If you can name it, the product was probably produced in Bristol.

Urban renewal was a craze in the 1960s, but Bristol did not have to wait that long. The Flood of 1955—the "Flood of the Century," as it was called—wreaked major havoc throughout New England. On August 13 and 14, 1955, Hurricane Connie, although no longer a hurricane threat, dropped several inches of water on the region. One week later, on August 19 and 20, Hurricane Diane charged through town, bringing more rain to the already swollen rivers. This proved too much for the Pequabuck River, and

the banks brimmed over into the streets of downtown Bristol, demolishing or damaging everything in its path.

As a result of this terrible incident that nature ruthlessly unleashed upon the region, the U.S. Army Corps of Engineers created flood control systems throughout New England. The Pequabuck River was rerouted to underground conduits, occasionally rising above the earth before spilling back into seclusion. Other buildings were later demolished to make way for the Centre Mall, which saw a brief moment of prosperity before losing its vendors to the thriving Route 6 corridor. The mall was eventually razed to make way for future plans.

Over the past half-century, many of the buildings have become homes for strange and inexplicable occurrences. Even the municipal buildings that were erected in the wake of the flood have taken on a curse of some sort where they began to mysteriously fall apart and malfunction. A lot of money has been put into the structures in the hopes of preventing them from crumbling altogether. Residents and visitors to downtown have seen and experienced countless apparitions of ghosts and other phenomena that accompany the various haunted places. Downtown Bristol suffered many casualties and losses in that flood. It is no wonder that there are many lingering spirits still looking for the familiar surroundings they once knew before the courses of nature brought about a change in their scenery and, in many cases, their lives.

Take a stroll around the city center and stop into a few shops. You might come in contact with one of the ghosts that occupy their time downtown. Even if you do not meet a revenant from the past, Bristol is still one of the more interesting historic places in Connecticut. Having a few spirits around to prove that cannot hurt.

BURLINGTON'S LAMPSON CORNER CEMETERY

This old burial ground, dating back to the early nineteenth century, is home to some active spirits. Many passersby have seen orbs and odd streaks of light emanating from the cemetery. There are trails that run along the edge of the graveyard, and hikers traversing those paths have caught glimpses of spectral sights that appear before them in the burial yard. Apparitions wandering among the graves have been a common recant among those who dare to venture toward the stones. One unsuspecting hiker came across the

cemetery and beheld a man in uniform standing near one of the tombstones. He stopped to watch the peculiar visage for a moment, noticing that the uniform looked very old. He called out to the person in request for the time, but the figure faded away in front of him. The curious hiker slowly crept toward the grave where the man had been and noticed, to his astonishment, that it was the monument of a World War II veteran.

Many others have witnessed such apparitions while visiting the burying yard. Paranormal groups have made it a point to check out the area in hopes of seeing either the strange orbs that float about the headstones or the man dressed in uniform. It has never been concluded as to whether the ghost is that of the person who is buried there or just biding an eternal visit. Perhaps one day someone visiting the cemetery may find the answer. Local historians are not sure how many graves are in the cemetery, as many may have been simple fieldstone or wooden markers that have long vanished from the curious eye. For now, it is a place where some do not necessarily lie in repose.

The official deed to the burial yard dates back to February 10, 1812, when Gad Frisbie, town treasurer of Burlington, paid Chauncey Brooks eleven dollars on behalf of the town for a parcel of land to be set aside as a public burial ground. The land, bounded south and west on the highway, totaled roughly ninety rods (a rod is an old unit of measurement equaling 16.5 feet in length).

There is also an account of an ill-omened patch of land along Route 69 between Burlington and Bristol that still reverberates with the sounds of an era long gone. Apparently there was a small community along that stretch of the thoroughfare that supposedly became infected with the smallpox virus. The disease spread through the community very quickly. Those who could escape did so, but most were not so lucky. Now the area is virtually a ghost town where the sounds of everyday life still permeate the air and witnesses see uncanny sights such as horses and buggies rolling ethereally on their way or semi-transparent figures moving along the road. One ghost is said to be a hitchhiker named Abigail. How the name Abigail came to be is one to be puzzled out. It is known that people did hitch rides way back in the days of the horse and wagon. As for why they are still there, conceivably the area could be a place where the boundary of life and death intersect, where the veil is so thin that it is sometimes crossed over, much like that of Bara-Hack in Pomfret. Whatever the case, the village may be gone, but the residents still linger in their daily toils long after their mortal tenure on earth. The area is at Lampson Corner on Route 69. Lampson Road Cemetery is also on Route 69.

THE OLD STATE HOUSE IN HARTFORD

Some places hold a few mysteries of the past that linger regardless of what may be there in the present. The Old State House in Hartford is reported to have a few illustrious ghosts roaming its corridors. Charles Bulfinch is said to be the architect who designed the structure that was completed in 1796. It was the center of Hartford until 1873, when the modern state house was built. It was declared a National Historic Landmark in 1960 and is one of the oldest remaining state houses in the country. It is presently run by the Old State House Association and is open Monday through Friday from 9:00 a.m. to 5:00 p.m. for self-guided tours. The building can also be rented for special occasions and hosts various events throughout the year.

When the Old State House was first ready for use, a local artist and museum keeper named Joseph Steward petitioned Governor Wolcott to have access to a third-floor chamber as an art studio. In return, he would paint portraits of famous Connecticut figures that would hang on the walls of the newly appointed building. Steward not only painted but also collected strange artifacts that he displayed in his studio. Customers flocked to his studio to get a glimpse of his collection. A light went off in Steward's head, and the Museum of Natural and Other Curiosities was born. For a mere two bits (twenty-five cents), people could gaze upon the horn of a unicorn or a two-headed calf that was displayed among other oddities not seen by the general populace until then. It was not long before his collection became too expansive for the cramped room in the state house, so he relocated the museum across the street. Steward died in 1822, and parts of his collection mysteriously disappeared, never to be seen again.

In 1975, the association created a reproduction of the museum on the second floor, using newspaper ads and other documents to create replicas of items Steward once displayed. They then added more items in keeping with what they feel would have been in Steward's taste. Perhaps that is why many think he is still in the old building. Footsteps are heard on the stairs going to the second level and also in the museum, which, upon investigation, seems to be completely void of the living. Maybe he is checking in from time to time to see what is new in his collection.

The spirit of Joseph Steward is not the only one said to be residing in the building. On May 26, 1647, forty-seven-year-old Alse Young was hanged for witchcraft in the meetinghouse square on the spot where the Old State House now sits. Alse was the first person to be executed for witchcraft in the colonies. In fact, Connecticut led the colonies in the witchcraft hysteria

from 1647 to 1663. Nine to eleven accused witches were reported hanged in the Nutmeg State during this period that ended twenty-nine years before the famous Salem witch trials of 1692. Alse's ghost is also said to be lingering in the area, still proclaiming her innocence. Perhaps it may be one of the other accused witches wanting to clear her name. Forty-six men and women were brought up on the charge of witchcraft from 1647 to 1697, although the last reported execution took place in 1663. Whoever the unidentified ghosts are that roam the sentinel walls of the historic house may be a mystery, but the museum is there, and so are some ethereal entities that seem to be taking care of it.

GILLETTE CASTLE

Atop a hill called the Seventh Sister, the last of a group of knolls known as the Seven Sisters, sits a medieval-style, twenty-four-room castle overlooking the Connecticut River. This stone edifice was owned and designed by William Hooker Gillette, famous for his stage role as Sherlock Holmes. In fact, his performances as the master detective numbered 1,300, the third-highest number of stage performances of a role in history.

Gillette was born on July 24, 1853, son of former U.S. senator Francis Gillette and Elizabeth Daggett Hooker Gillette, descendant of Thomas Hooker, founder of Hartford. Even as a child, young William knew his calling. He was very inventive and outgoing in his pursuits of the stage. These traits would follow him into adulthood. During his lifetime, he wrote two novels and thirteen plays, while also producing and directing plays starring none other than himself. His love of special effects led him to invent many stage tricks and lighting techniques. His last performance was at the Bushnell Theatre in 1936. Gillette died a year later on April 29, 1937. He is buried in the Hooker family cemetery in Farmington next to his wife.

His castle is a stone legacy born of an inventive and brilliant mind. Gillette designed the whole structure, right down to the slightest detail. The basic building took five years to construct. By 1919, the man who made Holmes famous was finally home. Through the years, he made enhancements upon his castle to suit his tastes. He also had a three-mile-long railroad that circled his property. Evidence of the railway still exists in the form of tunnels and the station, as the tracks were later torn up for hiking trails. Do not be dismayed, however, for one can still ride the famous span, as Lake Compounce later

Gillette Castle in East Haddam resembles a medieval fortress.

purchased portions of the railway to shuttle visitors around the pond at the amusement park.

Gillette died a widower with no children. His estate had no heirs, but in his will he ruled out the chance of his possessions going to unsavory prospects by adding the sentence that the property would never fall into the hands of some "blithering sap-head who has no conception of where he is or with what surrounded." In 1943, the State of Connecticut acquired the land and turned it into a park for all to enjoy, complete with camping, hiking, picnicking and, of course, tours of the castle. But is the medieval-style fortress haunted? The stone edifice imparts upon the gazer of the image a most confident feeling that Mr. Gillette could possibly still reside within.

Some have even claimed to see the ghostly image of the famous actor while touring the structure. Others claim to see the spirit of his gardener roaming the grounds, still tending to the massive landscaped flora. Many have felt sudden cold spots within the walls of the castle, but as it is made of stone, that could be entirely natural. There are reports of hikers and campers seeing the ghostly figure of someone moving about the castle during the winter and spring hours when it is otherwise closed to tours. Perhaps it may be William Gillette in search of an audience to once again entertain after a

long winter of solitude in the locked-up mansion. Or perhaps just the site of the edifice provokes the imagination, thus creating vivid scenes from the past within the mind's eye. Haunted or not, Gillette Castle State Park offers beautiful vistas of the Connecticut River and surrounding landscape, scenic hiking trails and a host of other outdoor activities. Bring a lunch, take a tour and relish in the architect of the castle. The famous actor just might treat you to a small performance while you are there.

NORTH PARKER HILL ROAD CEMETERY

It seems that ghosts of brides roam freely along Connecticut's countryside. These visions of matrimonial vows have stayed behind for some reason or another. In many cases, it is to finish a ceremony that was tragically interrupted. In the case of the North Parker Hill Road Cemetery, the bride *and* the groom have stuck around to make their eternal first appearance to whoever is in the area at the moment. No one knows who the spectral couple is, but witnesses have seen them crossing the road both to and from the burial ground.

Their identity remains a mystery, but the clue might lie in the stones for the adventurous to find out. Maybe the land was once their property before the cemetery came to be. Killingworth was settled in 1663, with its first town house being erected in 1736, so the hamlet is very old indeed. That gives time a lot of leeway for events to unfold. Killingworth has ten cemeteries; the oldest is the Union District Yard, which was laid out in 1738. Quite possibly, the couple is leaving their eternal resting place to visit friends or relatives buried in another one of the graveyards. If you see a misty couple dressed in nuptial duds crossing the road in front of the cemetery, try asking them where they are going. Wouldn't it be a startle if you got an answer?

UNION DISTRICT CEMETERY

In the quiet little town of Killingworth, there are more than enough legends and tales of the odd and peculiar that would rival the largest of cities. This next narrative is a combination of Rhode Island's Nellie Vaughn and Fall

River's Lizzie Borden. It is a strange tale of a woman whose uncontrollable temper got the best of her and her children.

Mrs. Higgins resided with her three children in a beat-up old cottage on what is now called Wolf Meadow Road. For unknown reasons, on October 14, 1799, she went crazy as a loon and, in her fit of rage, slit the throats of her children and reportedly tried to do herself in the same way. She survived, but the three children were buried the next day in an unmarked grave in the Union District Cemetery on North Roast Meat Hill Road. To this day, no grass, weed or lichen will grow on the site of the grave. As for Mrs. Higgins, according to the story published in *The History of Middlesex County* in 1819, Mrs. Higgins was never punished for the crime and lived the rest of her life with a black ribbon tied around her neck to cover the wound she had inflicted on herself. The villagers, though never taking action for her evil deed, vowed that she would never gain forgiveness from them until the hands of the old Union Church clock, which were petrified in place, came together at the witching hour.

GROVE STREET CEMETERY

Ron Kolek Jr. of New England Ghost Project examines the giant ball that mysteriously rotates in the Grove Street Cemetery.

The strange rotating ball in Putnam's Grove Street Cemetery is not small. The granite ball measures about three feet in diameter and is centered on a large monument. The weird aspect of this usual memorial is that the ball is mysteriously rotating on its base. The plot is centered in the middle of the necropolis. Scientists have no explanation for this bizarre behavior, but the ball is moving. Some claim that water seeping underneath might be causing the massive ball to roll. Another theory is that the climate changes cause expansion and contraction that make the sphere rotate.

As of this writing, the flat base of the ball is at about a ninety-degree angle from its original position and heading straight upward. No one knows when the ball began

moving on its obelisk. It could even be on its second rotation. Either the work of natural or supernatural forces, until the answer is found, it remains a true enigma for all to see.

BLOOD CEMETERY

One of the most commonly asked questions about the Quiet Corner's haunts is, "Where is Blood Cemetery?" The name alone is compelling, but the blood moniker is a common New England last name, so there really is no cause for alarm. Being located off Blood Road only proves that a family by that name once farmed the area in question.

As the legend goes, the youngest member of the Blood family went mad and killed the whole clan and then did himself in. They were all buried in a family plot on the property. Those who have been able to venture out into the graveyard claim to have witnessed apparitions roaming among the stones. The glowing forms seem to move about as if looking for something. They say that the area around the burial lot is full of negative energy. People become unnerved or even break out into a state of panic for no reason when near the lot. Once departed from the perimeter of the grounds, they regain their faculties.

Perhaps it is just the nature of the tale scaring the less brave legend trippers, or maybe there is something to the area. No one is telling much, and the place is deep in the woods on private property and very difficult to find. This modest narrative will hopefully satisfy the legend tripper's curiosity about Blood Cemetery and the legend that goes with it.

THE DEEP RIVER LIBRARY

In recent years, the Deep River Library has gained notoriety for having ethereal inhabitants roaming its aisles. Who they are and how long they have actually haunted the place is anybody's guess. The library started as a private home built in 1881 by Richard Pratt Spencer and his family. In *The History of Middlesex County* (1884), Spencer's home is described as such: "He has erected one of the most beautiful residences in Middlesex County, where he has surrounded himself with every comfort and luxury for the

gratification of his social and literary tastes. To this he has added a large and well-selected library containing many rate and interesting volumes."

Spencer owned an ivory trade manufacturing company, served as treasurer and president of the Deep River National Bank and represented the Twenty-first District in the state senate from 1882 to 1883. Spencer, born in Saybrook on February 12, 1820, married Clarissa Chapman in 1850. She died on December 16, 1871, leaving him with no children. In 1877, Spencer married Julia Seldon, with whom he had three children.

In 1932, the Deep River Library Association held a special meeting in regard to the purchase of the property from the estate of Julia Spencer to use as a permanent library. On May 10, 1933, the library now housed in the former Spencer home opened, with Clara E. Moore as its first librarian. The interior looks much as it did before renovating it to accommodate the many books and shelves. There is an old stove originally from the Spencer family that still sits in what used to be the kitchen.

As the building was a home at one time, it is quite possible that one or more of the Spencer family members may be still watching over their abode. Staff and patrons have witnessed a female spirit descending the main staircase, looking out of an upstairs window and even watching the children during story hour. Deep River library director Ann Paietta has had some experiences of her own. She has been the only person in the library on many occasions when she would suddenly hear movement upstairs. She would check out the situation, but each time, there would be no one up there. Many staff and regular patrons have heard their names called out, yet there is no one in the area. One staff member was alone in one of the rooms when she heard a woman clear her throat very close to where she was. She could easily see that she was the only person in the room at the time. Many who are in the library are suddenly overcome by the feeling that they are not alone, even though they may be the only living entity at a table or in an aisle. Ann related that many times they will open the library in the morning and puzzles that were put away the night before will be moved about, with pieces missing. The pieces are later found in strange places.

Many paranormal investigative groups have researched and held vigils at the library in hopes of finding out the identity of the spirits that still tenant the chambers. Their investigations have yielded everything from shadows, EVPs and cold spots to presences that are felt but not seen and apparitions. One is of a boy who has been spotted and heard on the upper floor. Michael Carroll, founder of New England Spiritual Team (NEST), was among the many who investigated the library. This is some of what transpired.

There were a couple of occasions on the fourth floor, which is the part of the library that is still left untouched from the original house. While doing an EVP session in the room where a spirit of a child has been seen, one person heard their name whispered in their ear distinctly. I personally checked the area on the below floors to see if anyone was there but the rest of the team was outside, four floors down, so it couldn't have been them. Also, the room right next to it, two people both had goose bumps, and the hair on their neck stood up. The windows were all closed, and it was really warm in the entire building so that [cold air] can be ruled out. Overall, we did catch a few interesting pictures and personal happenings.

NEST is a well-trained, professional organization. Arlene and I work with them whenever we get the opportunity, as they are thorough in their investigations. Unfortunately, we could not make the Deep River investigation, but we will definitely do an investigation, as the place seems to always assure the paranormal world that what you sometimes do not see, you can get—as paranormal evidence, that is.

NOAH WEBSTER HOUSE

Historic homes are almost guaranteed to have a spirit or two wandering about them. Even if they do not, the creaking and wind that howls through the settling cracks in the walls are enough to make you turn a few times wondering what that strange noise was. The Noah Webster House in West Hartford has reports of some old ghosts that may just be waiting to accompany visitors on a tour.

Noah Webster was a schoolmaster, Patriot, lawyer, legislator, farmer and, of course, author of the first American dictionary, released in 1828. Webster, a descendant of Pilgrim governor William Bradford, was born on October 16, 1758, in the home that now sports his name. The family land spanned 120 acres, so farming was inevitable. His Yale education, however, was purely his decision. Webster died on May 28, 1843, but left an American legacy that spans the ages. His home, a museum since 1966, has items he owned during his life, such as china, glassware, a desk and two clocks. Long after his death, the home remained occupied until it was given to the town in 1962. It became a National Historic Landmark that same year.

Touring old homes is always an extraordinary experience, and the Webster homestead is no different. If there are a few ghosts around, they only add to the charm. A female ghost in period clothing is claimed to have appeared in the second-floor window holding a candle. She is called the Lady in Blue, as she emits a bluish hue when observed. Staff members witnessed the basement door constantly opening, but they attributed it to drafts and put a heavy weight there to keep it closed. EVPs have been recorded in the home as well. Outside, people have seen orbs floating about the yard. Noah has not made a showing, but other past residents seem proud to be an eternal part of the house. Take a tour and relish in a piece of American history. Maybe see a few historic people while you are at it.

CONCLUSION

In the writing of this book, there were many places that, for one reason or another, had to be omitted. Some were demolished, put up for sale, closed down or developed upon, while others just decided not to advertise their resident ghosts. There are still plenty of places in the Nutmeg State to satisfy your appetite for the paranormal and legends that make Connecticut so mystical and magical. Enjoy, and as always, many happy haunts.

BIBLIOGRAPHY

Addeman, Joshua. *Manual with Rules and Orders for the Use of the General Assembly of the State of Rhode Island 1882–1883*. Providence, RI: E.I. Freeman and Co., 1882.

Arnold, James. *Vital Records of Rhode Island 1636–1850*. Providence, RI: Narragansett Historical Publishing Co., 1891–1912.

Barber, John Warner. *Connecticut Historical Collections*. New Haven, CT, 1836.

Belanger, Jeff. *Encyclopedia of Haunted Places*. Franklin Lakes, NJ: New Page Books, 2005.

Bell, Michael E. *Food for the Dead*. New York: Carroll & Graf Publishers, 2001.

Bolte', Mary, and Mary Eastman. *Haunted New England*. Riverside, CT: Chatham Press Inc., 1972.

Botkin, B.A. *A Treasury of New England Folklore*. New York: American Legacy Press, 1989.

Carter, Donald. *Connecticut's Seaside Ghosts*. Atglen, PA: Schiffer Books, 2008.

Citro, Joseph. *Cursed in New England*. Guilford, CT: Globe Pequot Press, 2004.

———. *Passing Strange*. New York: Houghton Mifflin Company, 1997.

D'Agostino, Thomas. *Abandoned Villages and Ghost Towns of New England*. Atglen, PA: Schiffer Books, 2008.

———. *A Guide to Haunted New England: Tales from Mount Washington to the Newport Cliffs*. Charleston, SC: The History Press, 2009.

———. *A History of Vampires in New England*. Charleston, SC: The History Press, 2010.

DeLuca, Dan W. *The Old Leather Man: Historical Accounts of a Connecticut and New York Legend*. Middletown, CT: Wesleyan University Press, 2008.

Drake, Samuel Adams. *New England Legends and Folklore in Poetry and Prose*. Boston: Little, Brown, and Co., 1883.

Foote, LeRoy W. "Caves in the Litchfield Hills." *Lure of Litchfield Hills Magazine* (June 1951).

———. "Our Connecticut Leather Man." *Lure of Litchfield Hills Magazine* (December 1952).

Fusco, C.J. *Old Ghosts of New England*. Woodstock, VT: Countryman Press, 2009.

Griggs, Susan J. *Folklore and Firesides in Pomfret, Hampton and Vicinity*. N.p.: Ingalls, 1950.

History of Middlesex County, Connecticut with Biographical Sketches of Its Prominent Men. New York: J.B. Beers and Co., 1884.

Jasper, Mark. *Haunted Inns of New England*. Yarmouth Port, MA: On Cape Publications, 2000.

Kuzmeskus, Elaine. *Connecticut Ghosts*. Atglen, PA: Schiffer Books, 2006.

Larned, Ellen D. *History of Windham County, Connecticut*. N.p.: self-published, 1880.

Myers, Arthur. *The Ghostly Register*. Chicago: Contemporary Books, 1986.

Oppel, Frank. *Tales of New England Past*. Secaucus, NJ: Castle Books, 1987.

Pitkin, David J. *Ghosts of the Northeast*. Salem, NY: Aurora Publications, 2002.

Pond, E.L. *The Tories of Chippeny Hill*. New York: Grafton Press, 1951.

Revai, Cheri. *Haunted Connecticut*. Mechanicsburg, PA: Stackpole Books, 2006.

Rondina, Christopher. *The Vampire Hunter's Guide to New England*. North Attleborough, MA: Covered Bridge Press, 2000.

Schlosser, S.E. *Spooky New England*. Guilford, CT: Globe Pequot Press, 2004.

Skinner, Charles M. *Myths and Legends of Our Own Land*. Philadelphia: J.P. Lippincott Company, 1896.

Smith, Diane. *Absolutely Positively Connecticut*. Guilford, CT: Globe Pequot Press, 2001.

Smitten, Susan. *Ghost Stories of New England*. Auburn, WA: Lone Pine Publishing, 2003.

Thompson, William O. *Coastal Ghosts and Lighthouse Lore*. Kennebunk, ME: 'Scapes Me, 2001.

———. *Lighthouse Legends and Hauntings*. Kennebunk, ME: 'Scapes Me, 2005.

Townshend, Doris B. *The Lost Village of the Higginbothams*. New York: Vantage Press, 1991.

WEBSITES

www.burlington.com
www.cityofmeriden.org
www.creepyct.com
www.ctgenweb.org
www.ctlandmarks.org
www.ctosh.org
www.damnedct.com
www.eaglehose.com
www.lighthouse.cc
www.millmuseum.org
www.newenglandghostproject.com
www.newenglandsite.com
www.newenglandspiritualteam.com
www.newhorizonsgenealogicalservices.com
www.northwestconnecticutparanormal.com
www.supernatural.inc
www.theshadowlands.net
www.wikipedia.org
www.woonsocket.org

About the Authors

Thomas D'Agostino has authored several books on the subject of the paranormal throughout New England, including *A Guide to Haunted New England* and *A History of Vampires in New England*. Tom has been a paranormal investigator for over twenty-nine years, having more than one thousand investigations to his credit, many written about in his books. Tom's love for history has been an asset in both his writing and paranormal research.

Arlene Nicholson is a professional photographer skilled in digital, film and darkroom processing. She has helped many paranormal groups discern the difference between natural images and defects in digital, film or developing process and what may be true paranormal evidence. Arlene is also gifted at dowsing and tarot cards.

Both Tom and Arlene have investigated countless places and have found compelling evidence that the paranormal realm exists and is able to communicate with the living in various ways. They travel the region speaking on their research and experiences. Their ghost stories and accounts have been written about in many publications and heard on radio and television.

Visit us at
www.historypress.net